the little book of
BUSINESS CARDS

includes matching letterheads and envelopes

David E. Carter

HARPER
DESIGN

An Imprint of HarperCollins*Publishers*

THE LITTLE BOOK OF BUSINESS CARDS
Copyright © 2005 by HARPER DESIGN and David E. Carter.

First published in 2005 by:
Harper Design,
An Imprint of HarperCollins*Publishers*
10 East 53rd Street
New York, NY 10022
Tel: (212) 207-7000
Fax: (212) 207-7654
HarperDesign@harpercollins.com
www.harpercollins.com

Distributed throughout the world by:
HarperCollins International
10 East 53rd Street
New York, NY 10022
Fax: (212) 207-7654

HarperCollins books may be purchased for educational, business, or sales promotional use. For information, please write: Special Markets Department, HarperCollins Publishers Inc., 10 East 53rd Street, New York, NY 10022.

Book design by Designs on You!
Suzanna and Anthony Stephens.

Library of Congress Control Number: 2004115492

ISBN: 0-06-074808-7

Printed in Hong Kong by Everbest Printing Company through Four Colour Imports, Louisville, Kentucky.
First Printing, 2005.

Table of Contents

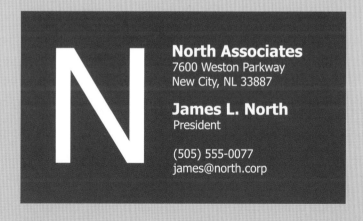

The Business Card has taken on a new importance in the last few years.

The increased use of email has led to a decline in business letters. The once dominant letterhead doesn't go into the mail with anywhere near the frequency it once did.

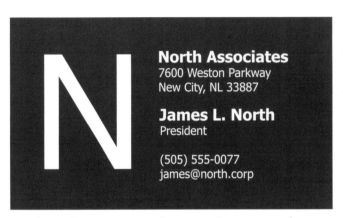

North Associates
7600 Weston Parkway
New City, NL 33887

James L. North
President

(505) 555-0077
james@north.corp

If the business *letter* has declined in importance, the business *card* is now even more powerful than it once was. Why? With so much impersonal communications, the personal contact that does take place is more crucial than ever. And, the aftereffect of personal contact is the business card. It is often the one item that is taken away from a meeting. It is the printed piece that goes back to the office and represents the company after personal contact has faded.

How important is the business card today? In my opinion, if this book were being done five to six years ago, there would be no question that the design process would begin with the letterhead. Now, the dominant design of the "letterhead set" may well begin with the business card.

In this book, the business card is the focus. The design begins there, and the envelope and letterhead follow. All, of course, have a consistent visual identity. (That hasn't changed even in the internet era.)

Business cards now have a major role: represent the company visually, and make follow-up contact easy.

The "recipes" for business cards (and matching letterheads and envelopes) in this book will give you a lot of inspiration to help you create just the right "first impression" for your next project.

How to get the most from this book.

If you design what is commonly called "letterhead sets," you know the problem. You need a fresh idea for a layout system. Well, this is the book for you. Inside, you will find nearly 270 pages of examples to inspire you, challenge you, and to give you the feeling "I'll do something like that."

If you are someone who starts at the back of the book and goes forward, then you have *already* seen every page of design within these covers. But, if you are just starting the book now, I'd suggest you make yourself free for an hour or so, and go through the book, page by page, from the front. The book has been organized to show you

- layouts with logos
- layouts with no logo, where type is the dominant design element
- layouts where there is no logo, and where the design itself is the main visual
- examples of software that can make your job easier
- thoughts about printing on the back

As you go through the book, "dog-ear" pages that you want to remember. Make mental notes about things that you think are important (you will know what they are.) Then, when you have that rush job and you need some help fast, this book will be ready for you.

Fonts

Most of this book has either a standard Times font or a basic Gothic font used for the name, address, etc. on the card, envelope, and letterhead. *This is for illustration purposes.* You are encouraged to look for other, more appropriate, fonts for your projects. (My recommendation for one great font book: **The Big Book of 5,000 Fonts**, by David E. Carter.) Don't just copy what you see in this book. Use it for a springboard for your own imagination. Remember that many fonts have lots of alternatives, such as light, condensed, demi, bold, extra bold, etc.

Paper Color—First of all, in this book, card, envelope, and letterhead on a single page are all shown in *different colors*. Here's why: if they were all the same color, they simply wouldn't stand out from each other.

So, am I suggesting that you design a letterhead set with different color paper for each item? No. Maybe. Or Yes. While the standard look is to have matching paper for all the items, that's an **old rule**, and one of the things that you'll find in this book is that we're advocating breaking many (if not all) of the **old rules**. So, YES, use different colors for envelopes, cards, and letterheads. Or, use matching paper for them. It's your choice.

Printed Colors—For many of the examples shown in this book, the colors break rules—the **old rules**. Some of the letterheads have backgrounds darker than usual. And, yes, I'm aware that type has to go there, but just how dark can the background be? The old rules said "use white or cream color" paper. Well, let's make the new rules:

> Rule One is "be creative."

The printed colors shown here are guidelines. Let your mind wander, and see just what you can come up with. To reiterate what I wrote earlier, **don't just copy what you see in this book; use it is a springboard for your own imagination.** If you see the design you like, and it's in red and blue, try it in purple and green. You get the idea. Your computer lets you mix CMYK to a huge number of color combinations. Use them.

One Last Word About Color—One and two-color printing is cheaper (considerably) than process color. However, since letterheads, cards, and envelopes are often printed in small quantities, consider this:

> Get yourself a good color printer, and print your letterhead at the **same time** you print the letter. Same for envelopes. As for cards, they are used more often now, so put your budget into getting a really great card, probably in process color.

Since a main premise of this book is that the business card is now the dominant element in the "letterhead set," the primary focus is on cards. So, on the pages that follow, *all the business cards are shown actual size.* Letterheads and envelopes are shown in reduced size.

More about size:

The size of the fonts used here, especially for envelopes and letterheads, was chosen mainly to make a good presentation for this book.

When you select type size for your letterhead set projects, don't follow the sizes shown here (to scale). It may not look right when it's enlarged to actual size. If you remember that the layouts shown were created to stimulate your imagination, you'll be ahead of the game.

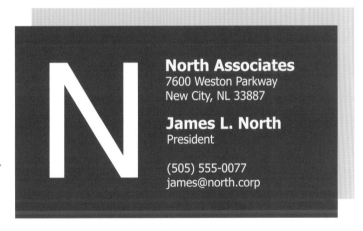

North Associates
7600 Weston Parkway
New City, NL 33887

James L. North
President

(505) 555-0077
james@north.corp

Notes

A lot of thought went into all those little pink notes on each page. Take the time to read them.

Nearly every page in the book has little notes (pink background, in handwriting). Read them. There's a lot of good information to be found there. You'll get everything from simple design tips to sources for stock art and photos.

OK. That's the intro. The rest of the book is all about design. Have fun!

North Associates
7600 Weston Parkway
New City, NL 33887
(505) 555-0077
www.north.corp

North Associates
7600 Weston Parkway
New City, NL 33887

This is a very basic system, with everything centered, includung type. As you use this book, remember that you can use ANY font, and ANY size, not just what is shown.

North Associates
7600 Weston Parkway
New City, NL 33887
(505) 555-0077

James L. North
President

james@north.corp

Note that the name and address are ABOVE the logo. The system at right has the logo on top. A subtle, but very different, look.

North Associates
7600 Weston Parkway
New City, NL 33545
(505) 555-0077
www.north.corp

North Associates

7600 Weston Parkway
New City, NL 33545
(505) 555-0077

James L. North

President

james@north.corp

In addition to the logo position being changed, the logo is smaller, and the font has been changed from Gothic to a Roman face.

North Associates
7600 Weston Parkway
New City, NL 33545

This design system focuses on the logo, which sits by itself at the left side of each piece. If you have a really good logo you want to spotlight, this is a good layout to use.

North Associates

7600 Weston Parkway
New City, NL 33545
(505) 555-0077
www.north.corp

North Associates

7600 Weston Parkway
New City, NL 33545
(505) 555-0077
www.north.corp

North Associates

James L. North
President

7600 Weston Parkway
New City, NL 33545

(505) 555-0077
james@north.corp

North Associates
7600 Weston Parkway
New City, NL 33545

(505) 555-0077
www.north.corp

North Associates
7600 Weston Parkway
New City, NL 33545

(505) 555-0077
james@north.corp

James L. North
President

Notice that the name of the individual is the only element (other than the logo) that has color.

North Associates
7600 Weston Parkway
New City, NL 33545

*The focus here is clearly on the individual, more than the company.
The business card layout is done so that the name is the focal point.*

North Associates
7600 Weston Parkway
New City, NL 33545
(505) 555-0077

This design is a standard flush left configuration, with the logo being at right. This layout allows the logo to be quite large, if this is appropriate.

North Associates

7600 Weston Parkway
New City, NL 33545
(505) 555-0077

James L. North
President

james@north.corp

North Associates
7600 Weston Parkway
New City, NL 33545

In this system, the logo can be placed in a variety of positions. It may be at the top (as on the letterhead) or centered (as on the card) or toward the bottom (as on the envelope.)

North Associates

This is a modification of the flush left system shown on the opposite page. Here, the name only is at the top, and the address data is at the bottom on each piece.

North Associates

Because the address data is at the bottom of each piece, the name on the card is moved to the right.

James L. North
President

james@north.corp

7600 Weston Parkway
New City, NL 33545
(505) 555-0077

North Associates

The logo is flush left to align with the type, but its size may vary.

7600 Weston Parkway
New City, NL 33545

7600 Weston Parkway
New City, NL 33887

(505) 555-0077

www.north.corp

North Associates

7600 Weston Parkway
New City, NL 33545

(505) 555-0077
www.north.corp

North Associates

7600 Weston Parkway
New City, NL 33545

(505) 555-0077
james@north.corp

James L. North
President

North Associates
7600 Weston Parkway
New City, NL 33545

Here, the only items on the left are the firm name and the logo. Everything else is on the right. However, the font still remains "flush left."

The envelope is a design exception, but remains its consistent look.

7600 Weston Parkway
New City, NL 33545

(505) 555-0077
www.north.corp

North Associates

7600 Weston Parkway
New City, NL 33545

(505) 555-0077
james@north.corp

North Associates

James L. North
President

North Associates
7600 Weston Parkway
New City, NL 33545

This variation is almost a mirror image of the one at left. Here, the logo and name are at right, with other type at the left. Note that the type is now set flush right.

North Associates

7600 Weston Parkway
New City, NL 33545

(505) 555-0077
www.north.corp

North Associates

1600 Weston Parkway
New City, NL 33545

338(505) 555-0077
james@north.corp

James L. North
President

The use of a red "hairline" gives this design an appealing distinctiveness. The color matches the logo.

North Associates

1600 Weston Parkway
New City, NL 33545

North Associates

7600 Weston Parkway
New City, NL 33545

(505) 555-0077
www.north.corp

Another variation would be to make the company name the same color as the line (as on the card here).

North Associates

7600 Weston Parkway
New City, NL 33545

(505) 555-0077
james@north.corp

James L. North
President

The same basic design takes on a different look: the color is now in contrast to the logo, and the line is thicker.

North Associates

7600 Weston Parkway
New City, NL 33545

North Associates

7600 Weston Parkway
New City, NL 33545

(505) 555-0077
www.north.corp

The use of a line has many visual possibilities. Here "the line" is actually small squares. The same concept can work with triangles, circles, or other shapes.

North Associates

7600 Weston Parkway
New City, NL 33545

505) 555-0077
james@north.corp

James L. North
President

North Associates

7600 Weston Parkway
New City, NL 33545

Note that the firm name is much larger than all the other type.

North Associates

1600 Weston Parkway
New City, NL 33545

(505) 555-0077
www.north.corp

North Associates

1600 Weston Parkway
New City, NL 33545

(505) 555-0077
james@north.corp

James L. North
President

Using a double hairline is another appealing variation of this design system.

North Associates

1600 Weston Parkway
New City, NL 33545

North Associates

7600 Weston Parkway
New City, NL 33545

(505) 555-0077
www.north.corp

This is a simple corporate look that puts the logo first on each element. This is good for embossed logo images.

North Associates

7600 Weston Parkway
New City, NL 33545

(505) 555-0077
james@north.corp

James L. North
President

North Associates

7600 Weston Parkway
New City, NL 33545

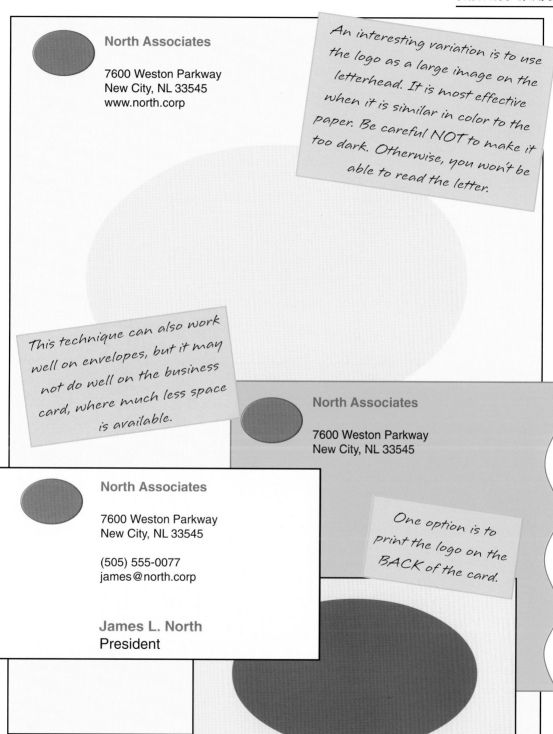

North Associates

7600 Weston Parkway
New City, NL 33545
www.north.corp

An interesting variation is to use the logo as a large image on the letterhead. It is most effective when it is similar in color to the paper. Be careful NOT to make it too dark. Otherwise, you won't be able to read the letter.

This technique can also work well on envelopes, but it may not do well on the business card, where much less space is available.

North Associates

7600 Weston Parkway
New City, NL 33545

North Associates

7600 Weston Parkway
New City, NL 33545

(505) 555-0077
james@north.corp

James L. North
President

One option is to print the logo on the BACK of the card.

North Associates

7600 Weston Parkway
New City, NL 33545

(505) 555-0077
www.north.corp

A plain white business card can take on a very dynamic look by simply printing the back with a color: here, solid red on the back gives the card a powerful third dimension.

North Associates

7600 Weston Parkway
New City, NL 33545

(505) 555-0077
james@north.corp

James L. North
President

North Associates

7600 Weston Parkway
New City, NL 33545

THE SECOND SHEET:

Letterheads may be used less often than in the past. When letters do go out, many are long. Plan for the second sheet. Instead of having simple plain paper, include it in the design system. Here, the logo is the only element found on the second sheet.

ANOTHER OPTION:
"Mix and Match" items can be very attractive. Make the envelope, letterhead and card different –but complimentary colors.

The logo and firm name appear in the upper left corner, and the address all appear in the lower left corner. (The card, with the name and title lines at right, are the only exception.)

North Associates

North Associates

7600 Weston Parkway
New City, NL 33545

(505) 555-0077
james@north.corp

James L. North
President

North Associates

7600 Weston Parkway
New City, NL 33545

7600 Weston Parkway
New City, NL 33545

(505) 555-0077
www.north.corp

This variation puts the firm name at the right corner, (with the type much larger), and all other items are in the lower left corner. (Again, the name and title lines are the exception.)

North Associates

North Associates

7600 Weston Parkway
New City, NL 33545

(505) 555-0077
james@north.corp

James L. North
President

Note that the firm name and person's name are now in color (to match the logo.)

North Associates

7600 Weston Parkway
New City, NL 33545

(505) 555-0077
www.north.corp

7600 Weston Parkway
New City, NL 33545

North Associates

Looking for something out of the ordinary: Vertical type for the name is a good start. Then, use double spacing between the lines.

7600 Weston Parkway

New City, NL 33545

(505) 555-0077

www.north.corp

North Associates

7600 Weston Parkway

New City, NL 33545

(505) 555-0077

james@north.corp

James L. North
President

North Associates

7600 Weston Parkway

New City, NL 33545

North Associates

Moving the logo and name to the right side gives you a different look.

North Associates

7600 Weston Parkway

New City, NL 33545

(505) 555-0077

james@north.corp

James L. North
President

North Associates

7600 Weston Parkway
New City, NL 33545

7600 Weston Parkway

New City, NL 33545

(505) 555-0077

www.north.corp

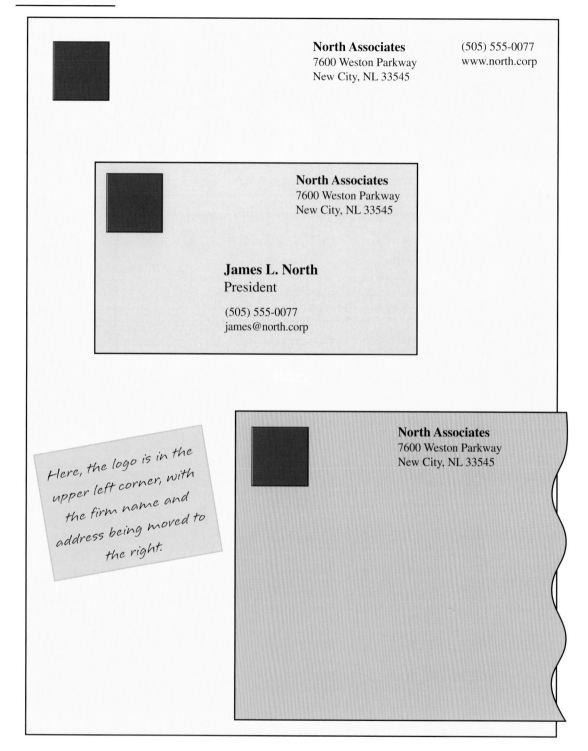

North Associates
7600 Weston Parkway
New City, NL 33545

(505) 555-0077
www.north.corp

North Associates
7600 Weston Parkway
New City, NL 33545

James L. North
President

(505) 555-0077
james@north.corp

Here, the logo is in the upper left corner, with the firm name and address being moved to the right.

North Associates
7600 Weston Parkway
New City, NL 33545

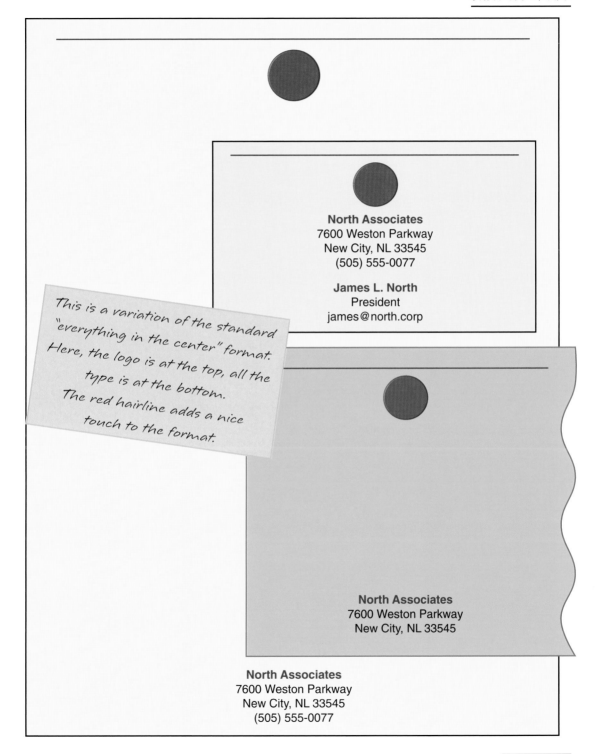

North Associates
7600 Weston Parkway
New City, NL 33545
(505) 555-0077

James L. North
President
james@north.corp

This is a variation of the standard
"everything in the center" format.
Here, the logo is at the top, all the
type is at the bottom.
The red hairline adds a nice
touch to the format.

North Associates
7600 Weston Parkway
New City, NL 33545

North Associates
7600 Weston Parkway
New City, NL 33545
(505) 555-0077

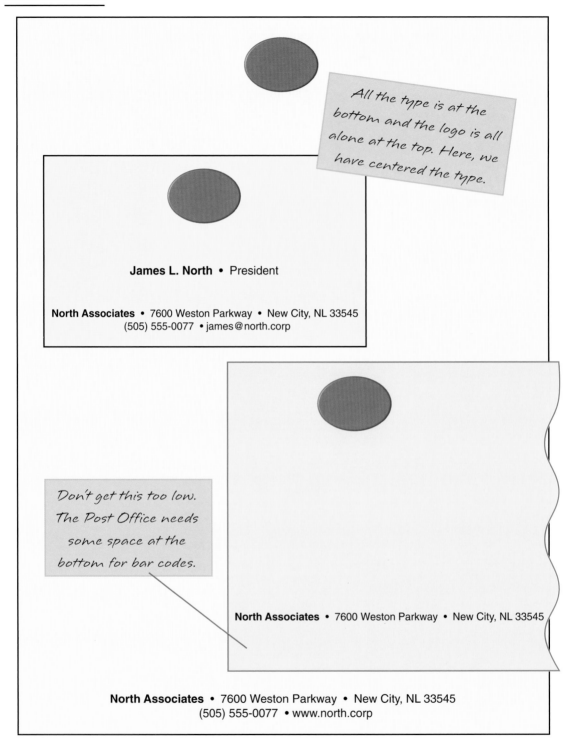

All the type is at the bottom and the logo is all alone at the top. Here, we have centered the type.

James L. North • President

North Associates • 7600 Weston Parkway • New City, NL 33545
(505) 555-0077 • james@north.corp

Don't get this too low. The Post Office needs some space at the bottom for bar codes.

North Associates • 7600 Weston Parkway • New City, NL 33545

North Associates • 7600 Weston Parkway • New City, NL 33545
(505) 555-0077 • www.north.corp

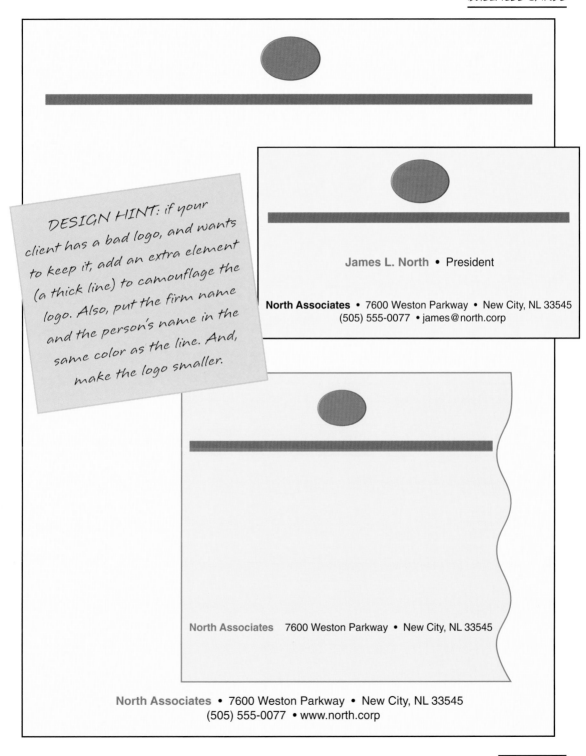

DESIGN HINT: if your client has a bad logo, and wants to keep it, add an extra element (a thick line) to camouflage the logo. Also, put the firm name and the person's name in the same color as the line. And, make the logo smaller.

James L. North • President

North Associates • 7600 Weston Parkway • New City, NL 33545
(505) 555-0077 • james@north.corp

North Associates 7600 Weston Parkway • New City, NL 33545

North Associates • 7600 Weston Parkway • New City, NL 33545
(505) 555-0077 • www.north.corp

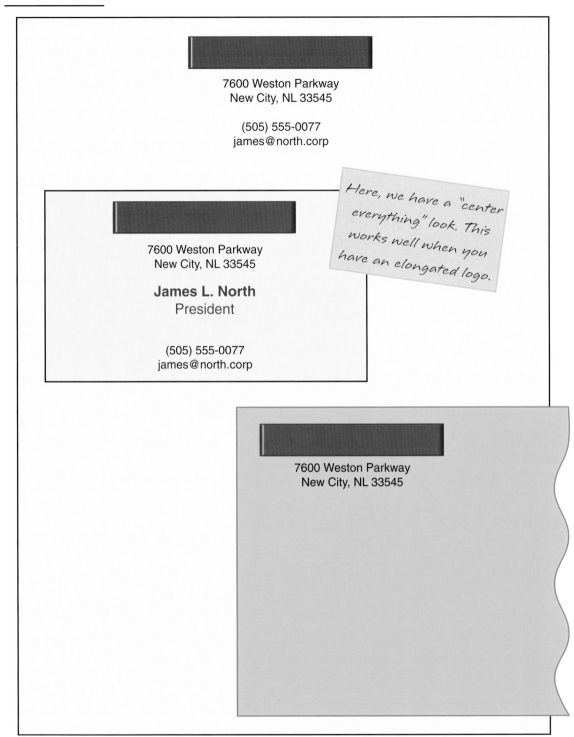

7600 Weston Parkway
New City, NL 33545

(505) 555-0077
james@north.corp

7600 Weston Parkway
New City, NL 33545

James L. North
President

(505) 555-0077
james@north.corp

Here, we have a "center everything" look. This works well when you have an elongated logo.

7600 Weston Parkway
New City, NL 33545

7600 Weston Parkway
New City, NL 33545

7600 Weston Parkway
New City, NL 33545

James L. North
President

(5 0 5) 5 5 5 - 0 0 7 7
j a m e s @ n o r t h . c o r p

7600 Weston Parkway
New City, NL 33545

While the "center everything" is an easy solution to an elongated logo, there are some quite creative options. Using forced letterspacing is shown here.

7600 Weston Parkway
New City, NL 33545

7600 Weston Parkway
New City, NL 33545

James L. North
President

(5 0 5) 5 5 5 - 0 0 7 7
james@north.corp

An option when the logo is elongated is to use forced justification on the type, and then have a contrasting color for a box below the logo.

7600 Weston Parkway
New City, NL 33545

If the logo is not especially good (you know what I'm talking about) this is a way to divert attention away from the design.

7600 Weston Parkway
New City, NL 33545

(505) 555-0077

WANT A DIFFERENT LOOK FOR CARDS? Try a vertical layout. Here we have taken a basic flush left layout with an elongated logo, but the card makes it look more progressive.

James L. North
President

7600 Weston Parkway
New City, NL 33545

(505) 555-0077
james@north.corp

7600 Weston Parkway
New City, NL 33545

Getting Lots of Information on a Business Card

When there is a lot of information to get on a business card, here are two techniques to make it as simple as possible.

North Associates

James L. North
President

1600 Weston Parkway
New City, NL 33545

Office Phone: (505) 555-0077
Fax: (505) 555-2417
Cell (505) 555-9989

james@north.corp
www.north.corp

This example is a bit crowded. The cards at bottom show better solutions.

North Associates
www.north.corp

James L. North
President

1600 Weston Parkway
New City, NL 33545

P (505) 555-0077
F (505) 555-2417
C (505) 555-9989
E james@north.corp

The oval shape of the background is the same as the logo.

North Associates
www.north.corp

James L. North
President

1600 Weston Parkway
New City, NL 33545

P (505) 555-0077
F (505) 555-2417
C (505) 555-9989
E james@north.corp

A square also works well for this.

North Associates

Adding a shape at the left of each element makes this a standout design.

North Associates

James L. North
President

7600 Weston Parkway
New City, NL 33545

(505) 555-0077
james@north.corp

North Associates

7600 Weston Parkway
New City, NL 33545

7600 Weston Parkway
New City, NL 33545

(505) 555-0077
www.north.corp

North Associates

7600 Weston Parkway
New City, NL 33545

(505) 555-0077
james@north.corp

A simple 12 point line at the edge of each piece adds visual impact.

North Associates

James L. North
President

7600 Weston Parkway
New City, NL 33545

(505) 555-0077
james@north.corp

REMEMBER:
If you like this basic design, you can still vary the: font, size, colors, logo size, position of elements, etc. This book has an almost infinite supply of ideas for you. Just open your mind.

North Associates

7600 Weston Parkway
New City, NL 33545

North Associates
7600 Weston Parkway
New City, NL 33545
(505) 555-0077

North Associates

James L. North
President

7600 Weston Parkway
New City, NL 33545

(505) 555-0077
james@north.corp

Using a strong border around each element gives it a "look at me" power.

North Associates
7600 Weston Parkway
New City, NL 33545

I know, the Post Office won't like this one. Maybe if the color is lighter.

North Associates

7600 Weston Parkway
New City, NL 33545

(505) 555-0077
james@north.corp

North Associates

James L. North
President

7600 Weston Parkway
New City, NL 33545

(505) 555-0077
james@north.corp

North Associates

7600 Weston Parkway
New City, NL 33545

Putting a border at the bottom of each piece is especially powerful if it's a gold foil stamp.

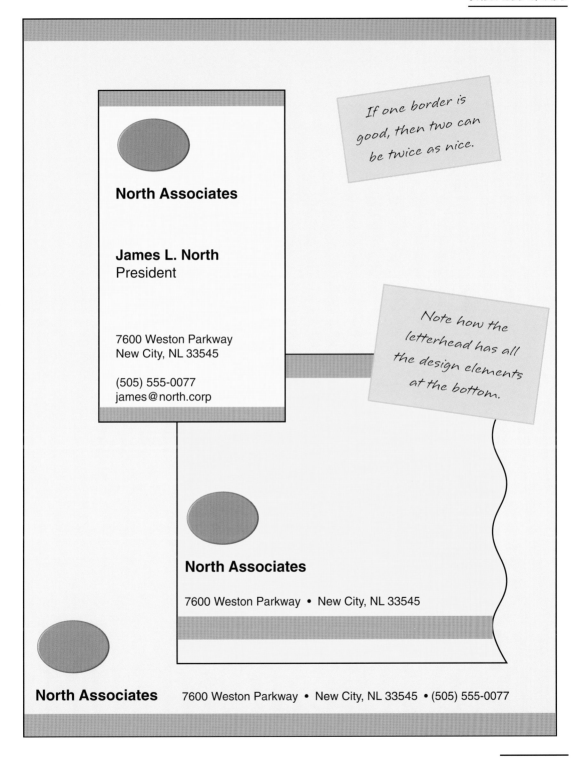

If one border is good, then two can be twice as nice.

Note how the letterhead has all the design elements at the bottom.

North Associates

James L. North
President

7600 Weston Parkway
New City, NL 33545

(505) 555-0077
james@north.corp

North Associates

7600 Weston Parkway • New City, NL 33545

North Associates 7600 Weston Parkway • New City, NL 33545 • (505) 555-0077

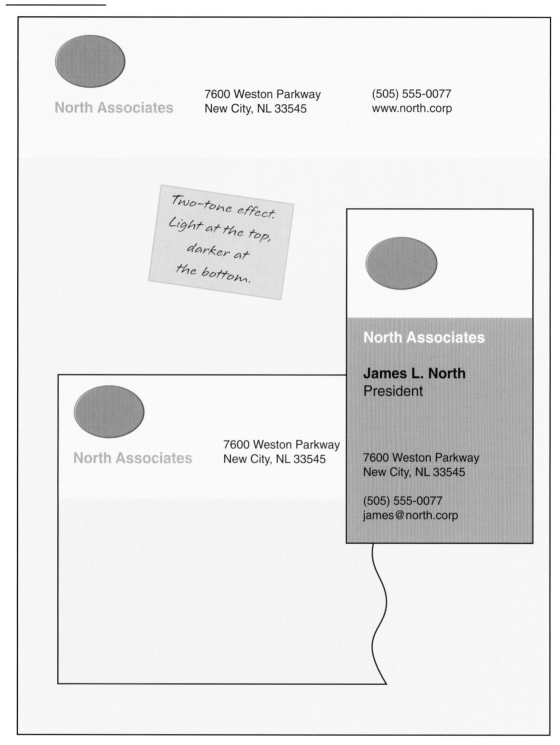

North Associates

7600 Weston Parkway
New City, NL 33545

(505) 555-0077
www.north.corp

Two-tone effect.
Light at the top,
darker at
the bottom.

North Associates

7600 Weston Parkway
New City, NL 33545

North Associates

James L. North
President

7600 Weston Parkway
New City, NL 33545

(505) 555-0077
james@north.corp

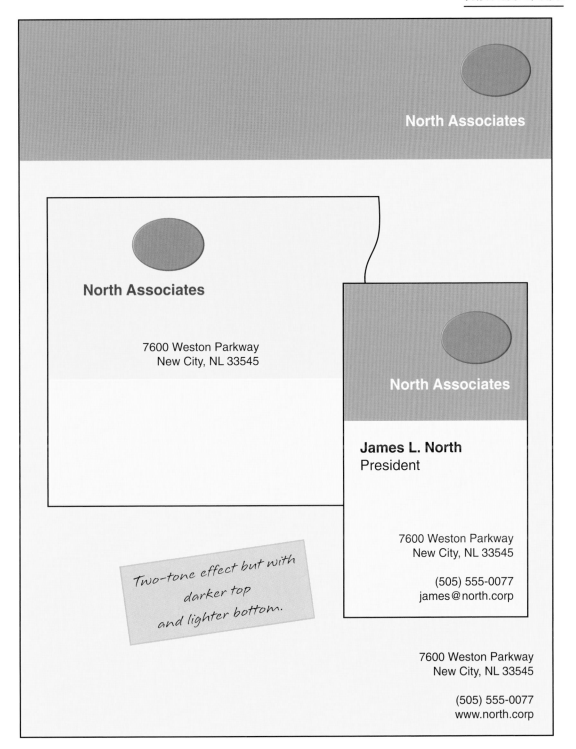

North Associates

North Associates

7600 Weston Parkway
New City, NL 33545

North Associates

James L. North
President

7600 Weston Parkway
New City, NL 33545

(505) 555-0077
james@north.corp

Two-tone effect but with darker top and lighter bottom.

7600 Weston Parkway
New City, NL 33545

(505) 555-0077
www.north.corp

North Associates

7600 Weston Parkway
New City, NL 33545

(505) 555-0077
www.north.corp

North Associates

James L. North
President

7600 Weston Parkway
New City, NL 33545

(505) 555-0077
james@north.corp

North Associates

7600 Weston Parkway
New City, NL 33545

The stripe in the middle of the card here highlights the individual, not the company. (But you can put the logo there if you wish.) Note that the stripe in the letterhead is muted, so that the words can be read.

North Associates

The logo rests on a light background, while all the type contrasts with its background. This is an excellent design for using a foil-stamped, embossed logo for maximum effect. The stripes at the top add to the appeal.

North Associates

James L. North
President

7600 Weston Parkway
New City, NL 33545

(505) 555-0077
james@north.corp

North Associates
7600 Weston Parkway
New City, NL 33545

7600 Weston Parkway
New City, NL 33545

(505) 555-0077
james@north.corp

North Associates

The logo is oversized here,
and also bleeds off the top
right edge of the page. This
configuration gives the logo
the dominant visual position
on the element.

North Associates

James L. North
President

7600 Weston Parkway
New City, NL 33545

(505) 555-0077
james@north.corp

7600 Weston Parkway
New City, NL 33545

North Associates

1600 Weston Parkway
New City, NL 33545

(505) 555-0077
james@north.corp

North Associates

James L. North
President

1600 Weston Parkway
New City, NL 33545

(505) 555-0077
james@north.corp

This is an interesting technique that can use type or a logo. The key is to be sure that the back ground image is not too dark. For the card, it works best on the back (shown at right). For envelopes, it works best... not at all. (Don't try this at home kids.)

James L. North
President

North Associates

1600 Weston Parkway
New City, NL 33545

(505) 555-0077
james@north.corp

Now that the price of four-color printing for cards is well within reach, many people, especially those in sales, are using their photo on cards. After seeing many of these, my best advice is don't make the photo too small. Or too big. As Goldilocks would say, it should be just right.

Do NOT, under any condition, put a salesperson's photo on the letterhead or envelope— no matter how good looking he is. Don't let the client talk you into it. Experienced designers know that one of the most important tasks is to save the client from his (her) own self-destructive tendencies.

James L. North
President

North Associates • 1600 Weston Parkway • New City, NL 33545 • (505) 555-0077
james@north.corp

North Associates

7600 Weston Parkway
New City, NL 33545

(505) 555-0077
www.north.corp

This design has a rich textural look that can make cards and letters command attention.

James L. North
President

North Associates

7600 Weston Parkway
New City, NL 33545

(505) 555-0077
james@north.corp

North Associates

7600 Weston Parkway
New City, NL 33545

North Associates

North Associates

North Associates

North Associates

North Associates

North Associates

North Associates

North Associates

North Associates

North Associates

North Associates

North Associates

North Associates

North Associates

North Associates

North Associates

North Associates

North Associates

North Associates

North Associates

7600 Weston Parkway
New City, NL 33545

(505) 555-0077

The step and repeat concept is brought to a wide stripe on the left of each item.

North Associates

North Associates

North Associates

North Associates

North Associates

North Associates

James L. North
President

7600 Weston Parkway
New City, NL 33545

(505) 555-0077
james@north.corp

North Associates

North Associates

North Associates

North Associates

North Associates

North Associates

North Associates

North Associates

North Associates

7600 Weston Parkway
New City, NL 33545

North Associates

*Bright Colors Work.
When it's appropriate,
think bright.*

North Associates

James L. North
President

7600 Weston Parkway
New City, NL 33545

(505) 555-0077
james@north.corp

7600 Weston Parkway
New City, NL 33545
(505) 555-0077

North Associates

7600 Weston Parkway
New City, NL 33545

(505) 555-0077
www.north.corp

North Associates

7600 Weston Parkway
New City, NL 33545

(505) 555-0077
james@north.corp

James L. North
President

The wide stripe at the top of all the elements is a very bold look.

North Associates

7600 Weston Parkway
New City, NL 33545

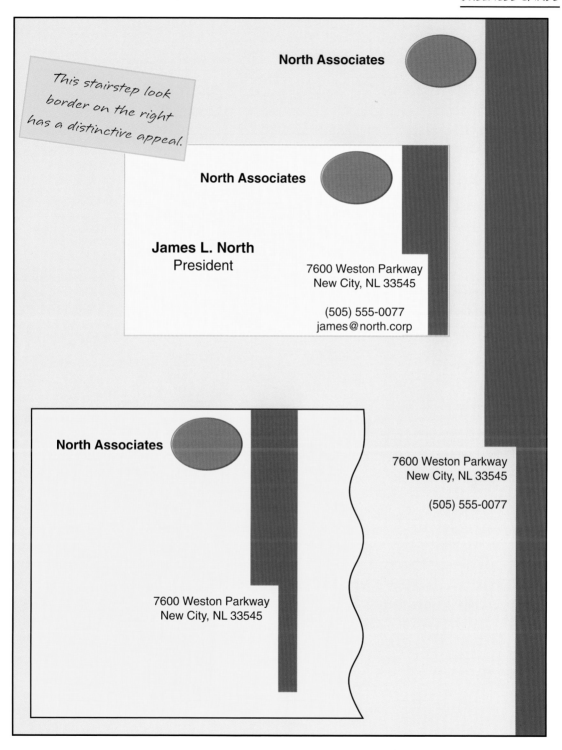

North Associates

This stairstep look border on the right has a distinctive appeal.

North Associates

James L. North
President

7600 Weston Parkway
New City, NL 33545

(505) 555-0077
james@north.corp

North Associates

7600 Weston Parkway
New City, NL 33545

(505) 555-0077

7600 Weston Parkway
New City, NL 33545

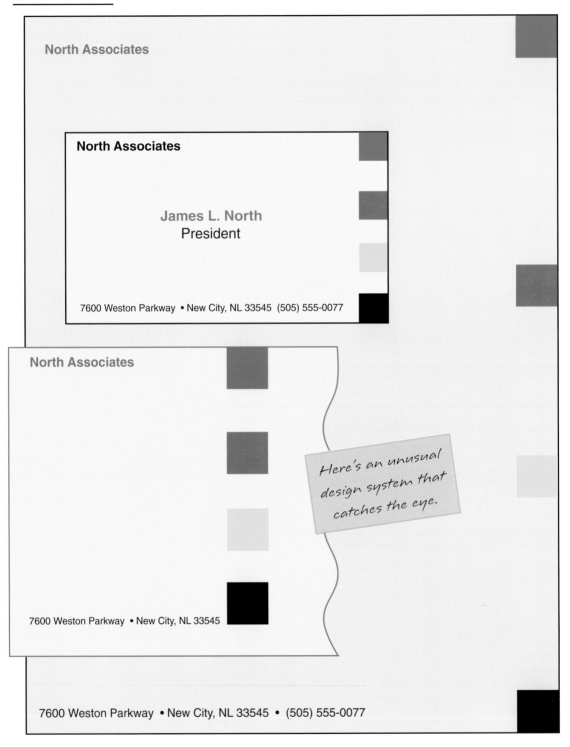

North Associates

North Associates

James L. North
President

7600 Weston Parkway • New City, NL 33545 (505) 555-0077

North Associates

Here's an unusual design system that catches the eye.

7600 Weston Parkway • New City, NL 33545

7600 Weston Parkway • New City, NL 33545 • (505) 555-0077

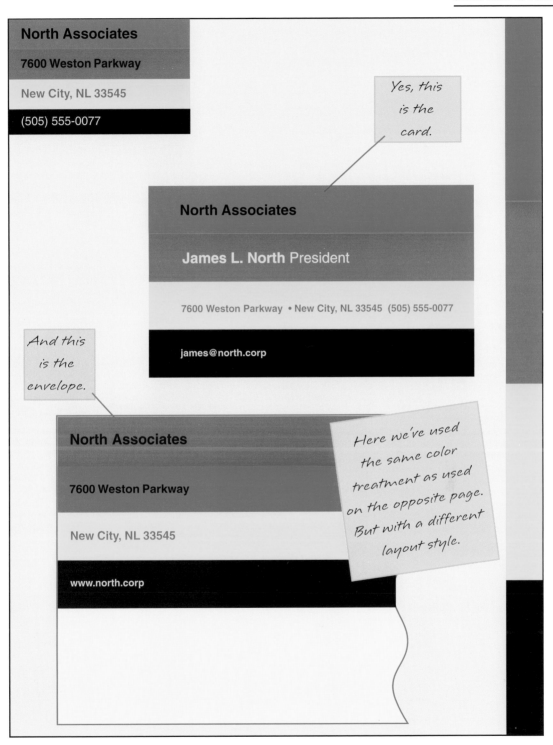

North Associates

7600 Weston Parkway
New City, NL 33545

(505) 555-0077

Vertical hairlines are most often on the left. This unique look lets you give the logo a position of high visibility.

James L. North
President

North Associates

7600 Weston Parkway
New City, NL 33545

(505) 555-0077
james@north.corp

North Associates

7600 Weston Parkway
New City, NL 33545

(505) 555-0077

James L. North
Chairman

Board Members

Budd Tugley

Juana Laya

Bjorn Tolouse

Bob Alou

Andrea Doria

Dot Kahm

Roseanna Babyruth

Clarke Smathers

Wendt Ofer IV

Will Knotgoe

Hugo Ferst

Phillip Scroodriva

Lois Canby

Muriel Seegars

Warren Pease

T-Bone Pickens

North Foundation
7600 Weston Parkway
New City, NL 33545

(505) 555-0077
www.north.corp

*This is the job we all dread: the one where all the board members have to be listed on the letterhead. The one exception: when the board members are VERY high profile people. Then, you want to put them on cards as well.
Hey, name dropping does have its benefits.*

North Associates
7600 Weston Parkway
New City, NL 33545

(505) 555-0077
james@north.corp

James L. North
Chairman

Back of card

James L. North
Chairman

Board Members

Budd Tugley	Wendt Ofer IV
Juana Laya	Will Knotgoe
Bjorn Tolouse	Hugo Ferst
Bob Alou	Phillip Scroodriva
Andrea Doria	Lois Canby
Dot Kahm	Muriel Seegars
Roseanna Babyruth	Warren Pease
Clarke Smathers	T-Bone Pickens

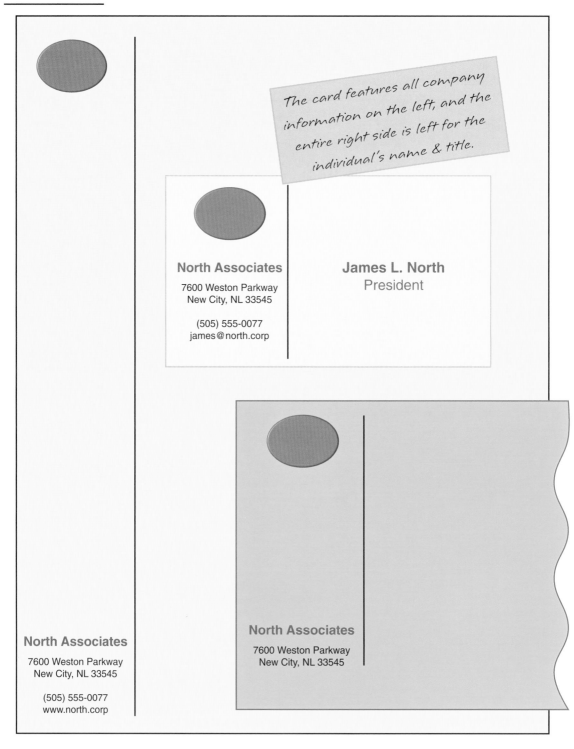

The card features all company information on the left, and the entire right side is left for the individual's name & title.

North Associates

7600 Weston Parkway
New City, NL 33545

(505) 555-0077
james@north.corp

James L. North
President

North Associates

7600 Weston Parkway
New City, NL 33545

(505) 555-0077
www.north.corp

North Associates

7600 Weston Parkway
New City, NL 33545

North Associates

7600 Weston Parkway • New City, NL 33545 • (505) 555-0077

North Associates

7600 Weston Parkway
New City, NL 33545

(505) 555-0077
james@north.corp

James L. North
President

North Associates

7600 Weston Parkway
New City, NL 33545

The size of the firm name and the hairline under the name are the strong visual elements here.

North Associates

North Associates

James L. North
President

7600 Weston Parkway • New City, NL 33545
(505) 555-0077 • james@north.corp

North Associates

This is a fairly simple design system, but the company name clearly is the dominant element.

7600 Weston Parkway • New City, NL 33545

7600 Weston Parkway • New City, NL 33545 • (505) 555-0077

North Associates
7600 Weston Parkway
New City, NL 33545

(505) 555-0077
www.north.corp

Rounded corners for business cards and letterheads add a touch of class.

North Associates

7600 Weston Parkway
New City, NL 33545

(505) 555-0077
james@north.corp

James L. North
President

Rounded corners for envelopes aren't practical, but you can simulate them by printing a round corner shape on them.

North Associates
7600 Weston Parkway
New City, NL 33545

North Associates

7600 Weston Parkway
New City, NL 33545

(505) 555-0077
james@north.corp

Putting a two-tone bar at the top of the page has many possibilities. If you aren't locked in with a certain color, experiment to see what interesting combinations you might discover.

North Associates

7600 Weston Parkway
New City, NL 33545

North Associates

7600 Weston Parkway
New City, NL 33545

(505) 555-0077
james@north.corp

James L. North
President

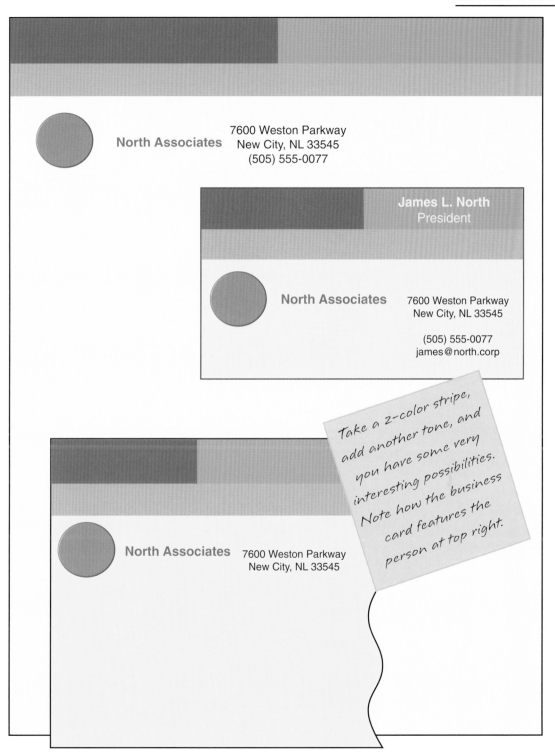

North Associates

7600 Weston Parkway
New City, NL 33545
(505) 555-0077

James L. North
President

North Associates

7600 Weston Parkway
New City, NL 33545

(505) 555-0077
james@north.corp

North Associates

7600 Weston Parkway
New City, NL 33545

Take a 2-color stripe, add another tone, and you have some very interesting possibilities. Note how the business card features the person at top right.

North Associates
7600 Weston Parkway
New City, NL 33545

338(505) 555-0077
www.north.corp

Put a multi-line box around each item and you have a piece that stands out. For the envelope, use white in the box, and it really commands attention.

North Associates
7600 Weston Parkway
New City, NL 33545

338(505) 555-0077
james@north.corp

James L. North
President

North Associates
7600 Weston Parkway
New City, NL 33545

Name and address go here

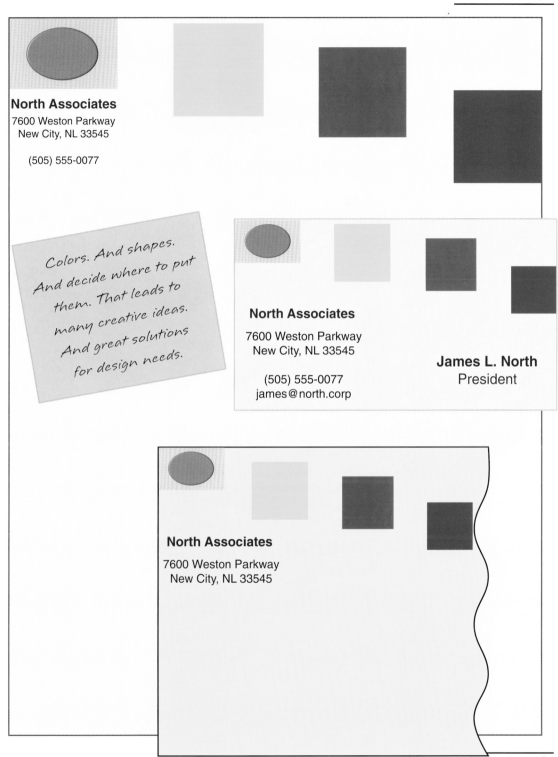

North Associates

7600 Weston Parkway
New City, NL 33545

(505) 555-0077

*Colors. And shapes.
And decide where to put
them. That leads to
many creative ideas.
And great solutions
for design needs.*

North Associates

7600 Weston Parkway
New City, NL 33545

(505) 555-0077
james@north.corp

James L. North
President

North Associates

7600 Weston Parkway
New City, NL 33545

Folding Card—Classy Look

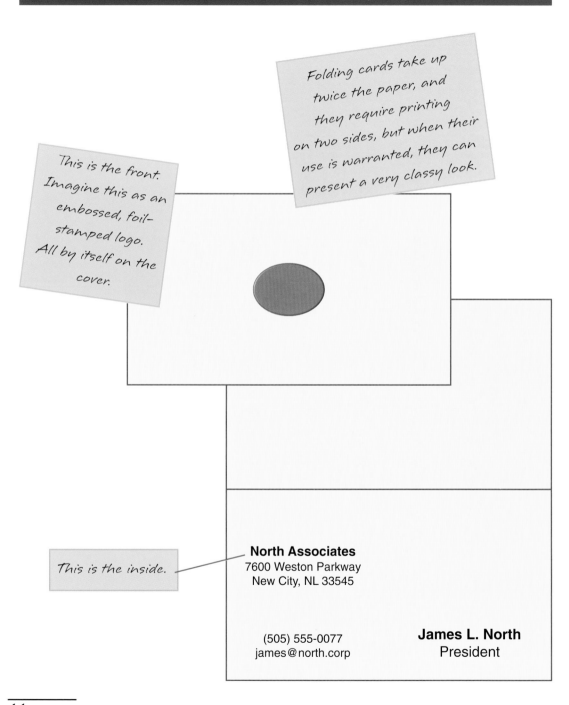

Folding cards take up twice the paper, and they require printing on two sides, but when their use is warranted, they can present a very classy look.

This is the front. Imagine this as an embossed, foil-stamped logo. All by itself on the cover.

This is the inside.

North Associates
7600 Weston Parkway
New City, NL 33545

(505) 555-0077
james@north.corp

James L. North
President

Folding Card—when you have LOTS to say

Sometimes, you will have a need to list a lot of locations and lots of phones, faxes, etc. The folding card is a good way to solve this problem.

This is the front. Here, we show the logo, company name, and address on the outside.

North Associates
7600 Weston Parkway
New City, NL 33545

This is the inside. The client insists on having all the details on the business card. Here's a way to do it.

North Associates

Mail address:
Post Office Box 2500
New City, NL 33545

Main Office: (505) 555-0077
Factory: (505) 555-1977
Warehouse: (505)555-4476

James L. North
President

Direct: (505) 555-0700
james@north.corp

Mobile: (505) 555-9989
Home: (505) 555-1754
Fax: (505) 555-2417

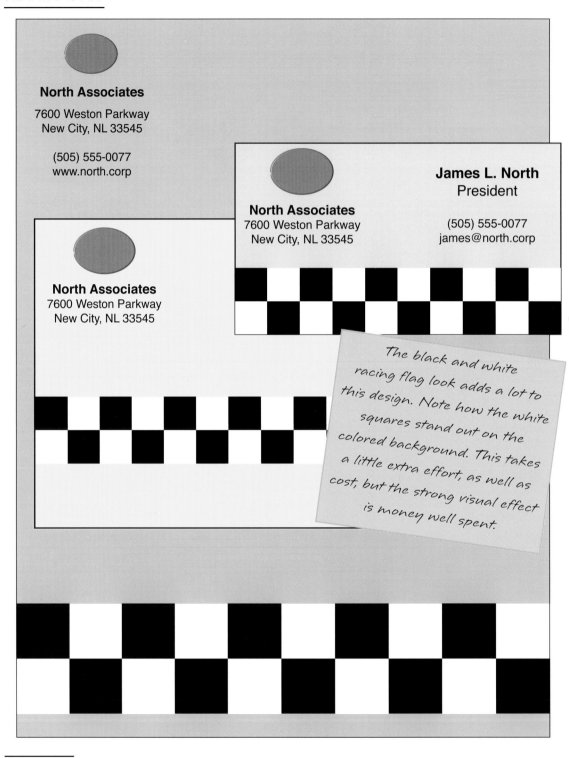

North Associates

7600 Weston Parkway
New City, NL 33545

(505) 555-0077
www.north.corp

James L. North
President

North Associates
7600 Weston Parkway
New City, NL 33545

(505) 555-0077
james@north.corp

North Associates
7600 Weston Parkway
New City, NL 33545

The black and white racing flag look adds a lot to this design. Note how the white squares stand out on the colored background. This takes a little extra effort, as well as cost, but the strong visual effect is money well spent.

North Associates
7600 Weston Parkway New City, NL 33545
(505) 555-0077

North Associates
7600 Weston Parkway
New City, NL 33545

(505) 555-0077
james@north.corp

Printing eye-catching shapes in the right and left margins of the letterhead makes for good design. Let your mind wander to get other shapes.

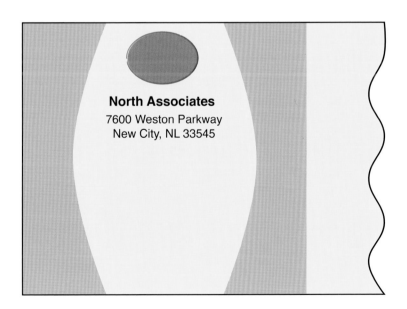

North Associates
7600 Weston Parkway
New City, NL 33545

The shape of the paper can give you a system that shouts "look at me." Try different shapes for the card and for the letterhead. (You don't have this option with envelopes.)

Getting odd shaped cards and letterheads is as simple as deciding what the shape will be before you print the items. Printing comes first, then the pieces are cut to your specs.

North Associates
7600 Weston Parkway
New City, NL 33545

(505) 555-0077
james@north.corp

James L. North
President

Above is the card as printed. At right is the card after being cut.

North Associates
7600 Weston Parkway
New City, NL 33545

(505) 555-0077
james@north.corp

James L. North
President

North Associates
7600 Weston Parkway
New City, NL 33545

(505) 555-0077
www.north.corp

Here's one interesting shape for the letterhead. The lighter areas are good for the message, and the shape and the strong colors on the outside are quite unique.

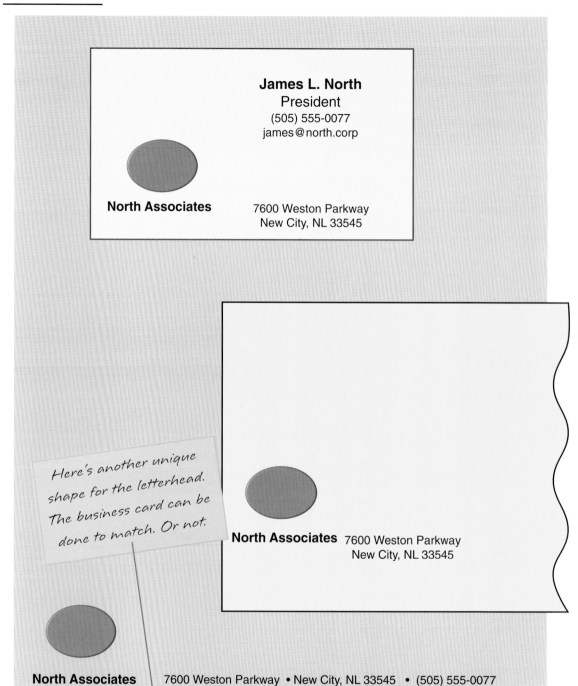

James L. North
President
(505) 555-0077
james@north.corp

North Associates 7600 Weston Parkway
New City, NL 33545

Here's another unique shape for the letterhead. The business card can be done to match. Or not.

North Associates 7600 Weston Parkway
New City, NL 33545

North Associates 7600 Weston Parkway • New City, NL 33545 • (505) 555-0077

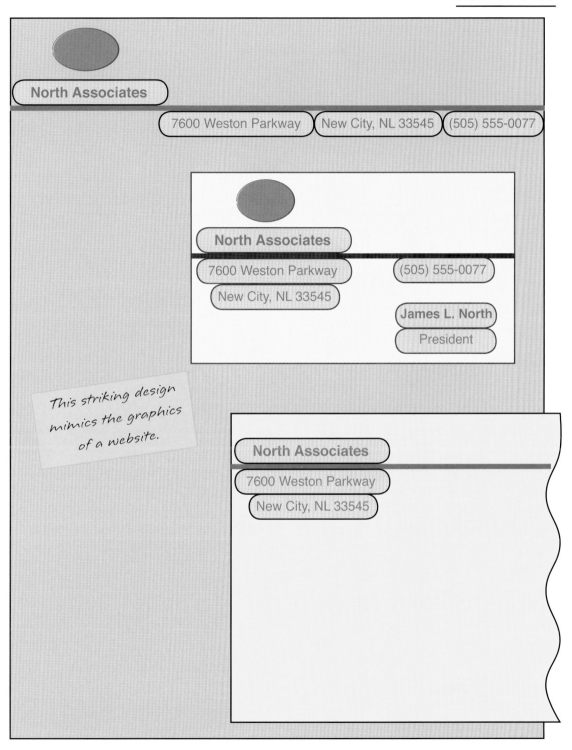

North Associates

7600 Weston Parkway New City, NL 33545 (505) 555-0077

North Associates

7600 Weston Parkway (505) 555-0077

New City, NL 33545

James L. North

President

This striking design mimics the graphics of a website.

North Associates

7600 Weston Parkway

New City, NL 33545

North Associates

7600 Weston Parkway
New City, NL 33545

(505) 555-0077
www.north.corp

North Associates

7600 Weston Parkway
New City, NL 33545

(505) 555-0077
james@north.corp

James L. North
President

The round logo is enhanced by the four circles at the right of each piece.

North Associates

7600 Weston Parkway
New City, NL 33545

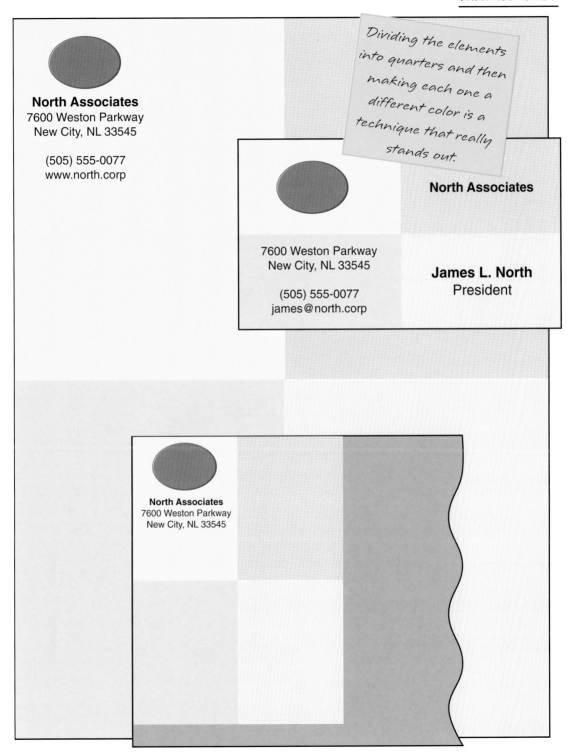

North Associates
7600 Weston Parkway
New City, NL 33545

(505) 555-0077
www.north.corp

North Associates

7600 Weston Parkway
New City, NL 33545

(505) 555-0077
james@north.corp

James L. North
President

Dividing the elements into quarters and then making each one a different color is a technique that really stands out.

North Associates
7600 Weston Parkway
New City, NL 33545

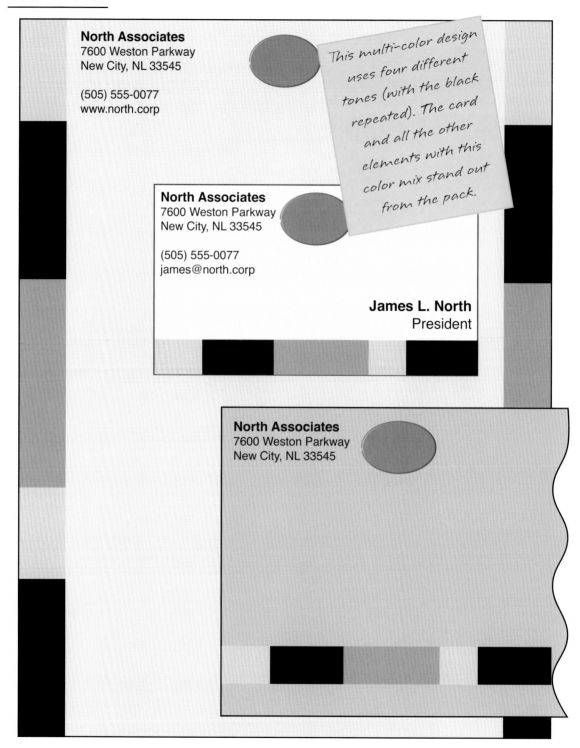

North Associates
7600 Weston Parkway
New City, NL 33545

(505) 555-0077
www.north.corp

North Associates
7600 Weston Parkway
New City, NL 33545

(505) 555-0077
james@north.corp

James L. North
President

This multi-color design uses four different tones (with the black repeated). The card and all the other elements with this color mix stand out from the pack.

North Associates
7600 Weston Parkway
New City, NL 33545

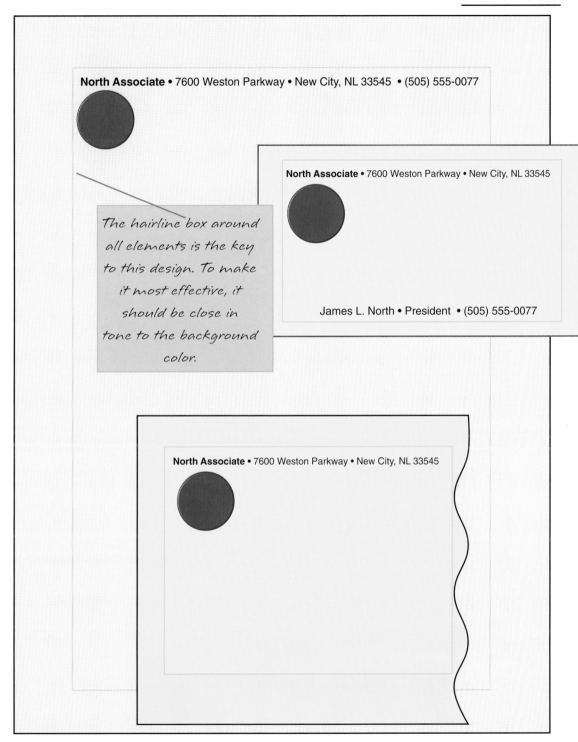

North Associate • 7600 Weston Parkway • New City, NL 33545 • (505) 555-0077

North Associate • 7600 Weston Parkway • New City, NL 33545

James L. North • President • (505) 555-0077

The hairline box around all elements is the key to this design. To make it most effective, it should be close in tone to the background color.

North Associate • 7600 Weston Parkway • New City, NL 33545

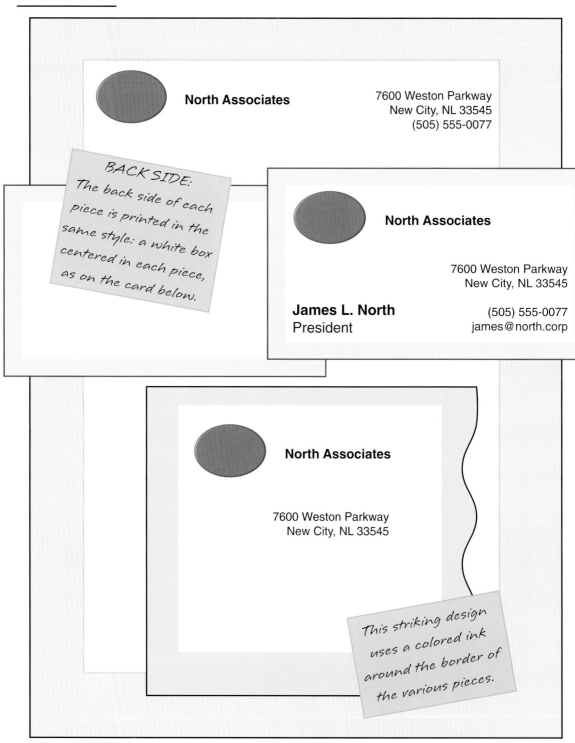

North Associates

7600 Weston Parkway
New City, NL 33545
(505) 555-0077

BACK SIDE:
The back side of each piece is printed in the same style: a white box centered in each piece, as on the card below.

North Associates

7600 Weston Parkway
New City, NL 33545

James L. North
President

(505) 555-0077
james@north.corp

North Associates

7600 Weston Parkway
New City, NL 33545

This striking design uses a colored ink around the border of the various pieces.

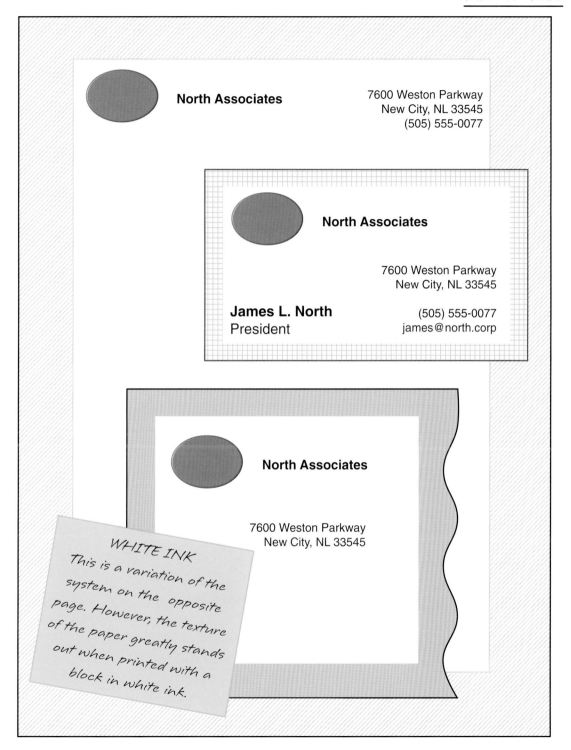

North Associates

7600 Weston Parkway
New City, NL 33545
(505) 555-0077

North Associates

7600 Weston Parkway
New City, NL 33545

James L. North
President

(505) 555-0077
james@north.corp

North Associates

7600 Weston Parkway
New City, NL 33545

WHITE INK
This is a variation of the system on the opposite page. However, the texture of the paper greatly stands out when printed with a block in white ink.

North Associates

7600 Weston Parkway
New City, NL 33545

(505) 555-0077
www.north.corp

This design has the appearance of a note book. Using rounded edges on the right and the stripes at left make this a very striking design system.

James L. North
President

North Associates

7600 Weston Parkway
New City, NL 33545

(505) 555-0077
james@north.corp

North Associates

7600 Weston Parkway
New City, NL 33545

It is impractical to try to have rounded corners on envelopes, but you can still carry the design system through with the stripe at the left.

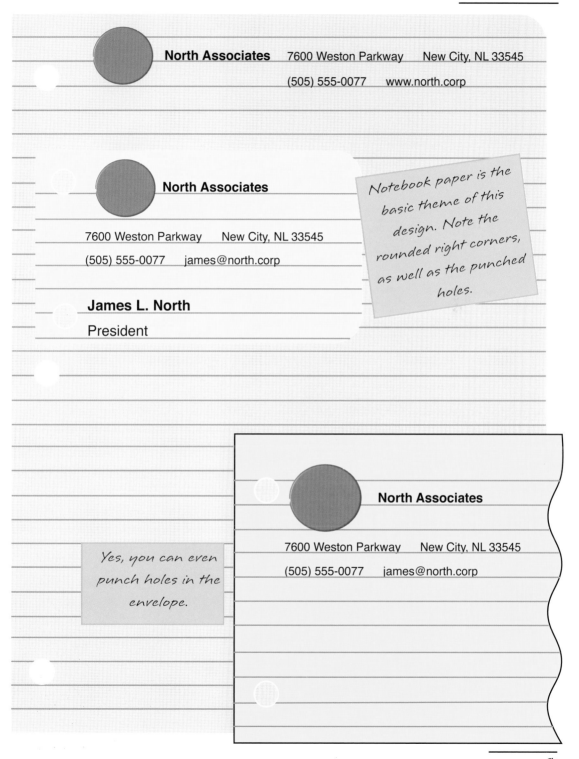

North Associates 7600 Weston Parkway New City, NL 33545

(505) 555-0077 www.north.corp

North Associates

7600 Weston Parkway New City, NL 33545

(505) 555-0077 james@north.corp

James L. North

President

Notebook paper is the basic theme of this design. Note the rounded right corners, as well as the punched holes.

North Associates

7600 Weston Parkway New City, NL 33545

(505) 555-0077 james@north.corp

Yes, you can even punch holes in the envelope.

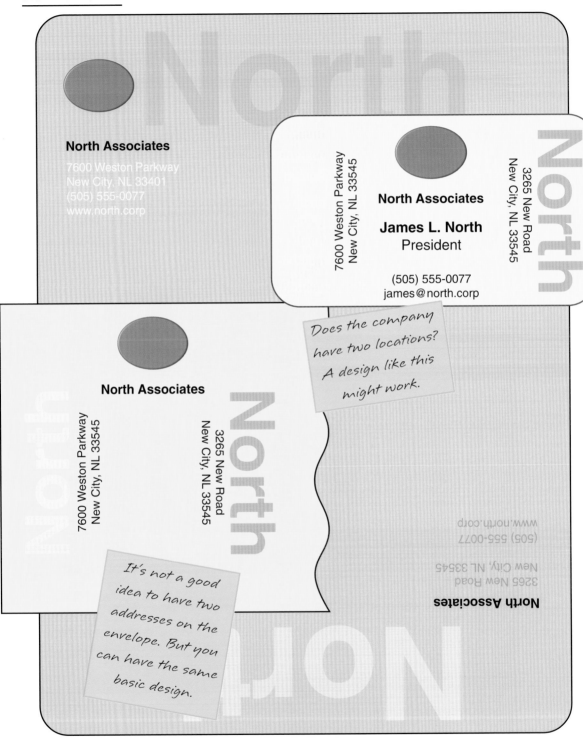

North Associates

7600 Weston Parkway
New City, NL 33401
(505) 555-0077
www.north.corp

North Associates

James L. North
President

7600 Weston Parkway
New City, NL 33545

3265 New Road
New City, NL 33545

(505) 555-0077
james@north.corp

Does the company have two locations? A design like this might work.

North Associates

7600 Weston Parkway
New City, NL 33545

3265 New Road
New City, NL 33545

It's not a good idea to have two addresses on the envelope. But you can have the same basic design.

North Associates

3265 New Road
New City, NL 33545
(505) 555-0077
www.north.corp

North Associates

North Associates
7600 Weston Parkway
New City, NL 33545
(505) 555-0077
james@north.corp

James L. North
President

7600 Weston Parkway
New City, NL 33401
(505) 555-0077
www.north.corp

North

How to simulate EMBOSSING:
1. Set the type large. Small
type won't show up well.
2. The first layer (top) is
the same color as the background.
3. The second color (back) is a
shade darker than the top layer.)
And you have the embossed
look. But don't stop there,
try using totally different colors for
different embossed "looks".

North Associates
7600 Weston Parkway
New City, NL 33545

North

North

North

NORTH

**North
Associates**

7600 Weston
Parkway

New City, NL
33545

Phone (505)
555
0077

Fax (505)
555
0700

www.
north.
corp

The use of a tall stack of type gives this system a very unique look.

NORTH

**North
Associates**

7600 Weston Parkway

New City, NL 33545

(505) 555-0077

**James E. North
President**

NORTH

**North
Associates**

7600 Weston Parkway

New City, NL 33545

NORTH
7600 Weston Parkway
New City, NL 33545
(505) 555-0077

Letter to: _____
Attn: _____
Address: _____
City _____
State, Zip_____

The black boxes form the basic look here, but the address box makes the letterhead distinctive. Note how this look translates to the card and envelope.

NORTH
7600 Weston Parkway
New City, NL 33545
(505) 555-0077

Notes _____

NORTH
7600 Weston Parkway
New City, NL 33545
(505) 555-0077

James E. North
President

Notes _____

Maximize personal contact. Make a note on the card, such as a price, or e-mail address, etc.

Really get attention for your letter. Put a handwritten note on the envelope.

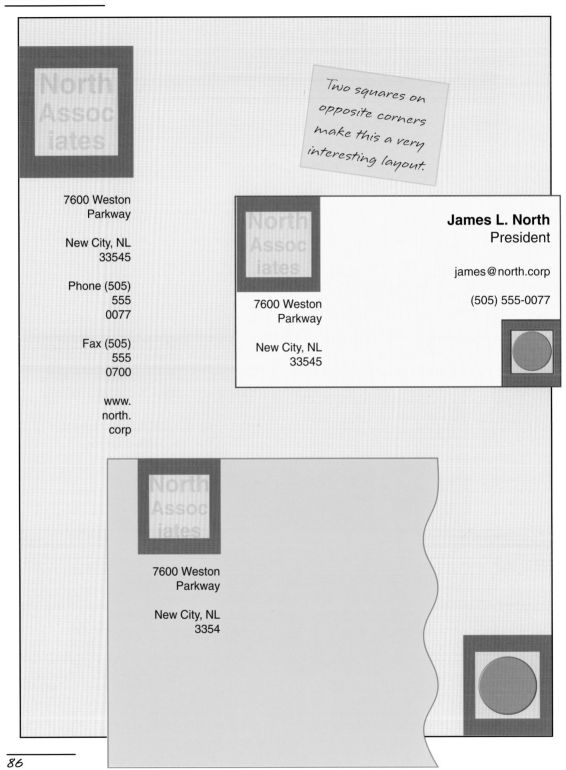

North
Assoc
iates

7600 Weston
Parkway

New City, NL
33545

Phone (505)
555
0077

Fax (505)
555
0700

www.
north.
corp

Two squares on opposite corners make this a very interesting layout.

North
Assoc
iates

7600 Weston
Parkway

New City, NL
33545

James L. North
President

james@north.corp

(505) 555-0077

North
Assoc
iates

7600 Weston
Parkway

New City, NL
3354

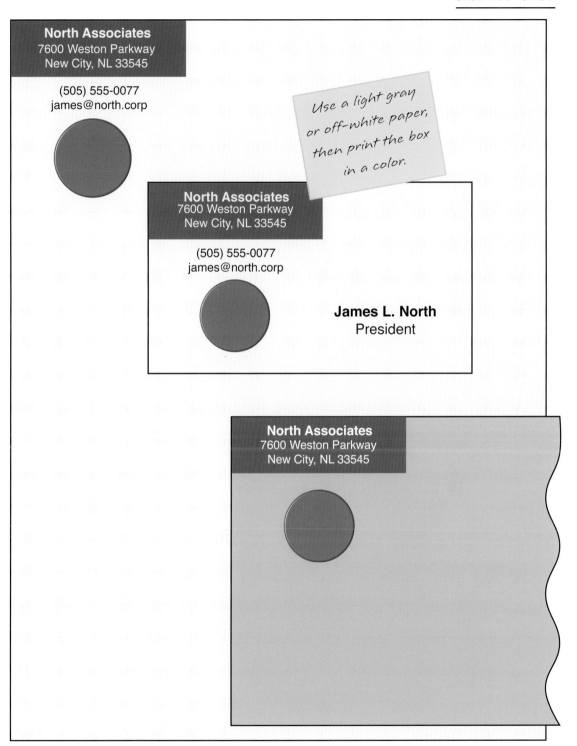

North Associates
7600 Weston Parkway
New City, NL 33545

(505) 555-0077
james@north.corp

Use a light gray
or off-white paper,
then print the box
in a color.

North Associates
7600 Weston Parkway
New City, NL 33545

(505) 555-0077
james@north.corp

James L. North
President

North Associates
7600 Weston Parkway
New City, NL 33545

ENVELOPES
There are many different envelopes that are stock items. You aren't restricted to the standard #10 envelope. Consider the larger #11 size.

Some envelopes have the flap at one end (top example) instead of along the top (example shown at left).

You can print the flap a different color from the envelope to add emphasis to an address or logo.

Ask your favorite printer to show you some unusual envelope styles.

Remember, let your imagination run wild.

So you don't have a logo?

Use

TYPE

Creatively

ACROPOLIS RESTAURANT

7600 Weston Parkway
New City, NL 33545
(505) 555-0077

When you don't have a logo, the name in type assumes extra responsibility. For that reason, the font size is usually larger than if you had a logo.

James L. North
President

ACROPOLIS RESTAURANT

7600 Weston Parkway
New City, NL 33545

(505) 555-0077
james@acropolis.corp

ACROPOLIS RESTAURANT

7600 Weston Parkway
New City, NL 33545

You can make the envelope stand out more by moving the type down lower. (It is almost like there is an invisible logo.).

*Font: Acropolis
Source: P22.com*

Double Vision

If there is no logo, look to the firm name for ideas on what might be a good font.

Double Vision

7600 Weston Parkway
New City, NL 33545

James L. North
President

(505) 555-0077
james@doublevision.corp

Double Vision

7600 Weston Parkway
New City, NL 33545

Font: Double Hitter
Source: typeart.com

Captain Billy's Fun House

7600 Weston Parkway New City, NL 33545 (505) 555-0077
www.thecaptain.corp

William B. Campbell
The Captain

Captain Billy's Fun House

7600 Weston Parkway New City, NL 33545 (505) 555-0077
billy@thecaptain.corp

Captain Billy's Fun House

7600 Weston Parkway New City, NL 33545

Font: Telegram
Source: itcfonts.com

The Back Room

7600 Weston Parkway New City, NL 33545 (505) 555-0077
www.backroom.corp

When the business name doesn't describe what it is, you might consider using an additional line of type at the bottom of each piece. Here, the second line really makes this an interesting business.

The Back Room

James L. North
President

7600 Weston Parkway New City, NL 33545 (505) 555-0077
james@north.corp

Really Good Salvaged Stuff

The Back Room

7600 Weston Parkway New City, NL 33545

Really Good Salvaged Stuff

Really Good Salvaged Stuff

Font: Stencil Full Danse
Source: 2Rebels.com

7600 Weston Parkway New City, NL 33545 (505) 555-0077
www.encore.corp

James L. North
President

7600 Weston Parkway New City, NL 33545 (505) 555-0077
james@encore.corp

almost new clothing, cheap

Ditto for the descriptor line.

This business is giving a second life to clothing. Look for a font that stands out and creates an impression that conveys that message.

7600 Weston Parkway New City, NL 33545

almost new clothing, cheap

almost new clothing, cheap

Font: Electric Weasel
Source: synfonts.com

BeA(H PARTY

7600 Weston Parkway
New City, NL 33545
(505) 555-0077

James L. North
President

BeA(H PARTY

7600 Weston Parkway
New City, NL 33545

(505) 555-0077
james@beachparty.corp

There are thousands of fonts available for purchase and immediate download on the internet. When you don't have a logo, find the "just right" font.

BeA(H PARTY

7600 Weston Parkway
New City, NL 33545

Small touch: Note how the use of 3 asterisks (***) at each side of the name adds visual appeal to the name.

Font: Hopscotch
Source: fonthead.com

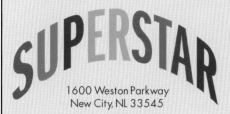

1600 Weston Parkway
New City, NL 33545

(505) 555-0077
www.superstar.corp

No logo?
No problem.
To make "Superstar" into a
distinctive identity, this icon
was created in TypeStyler in
about 43 seconds.

SUPERSTAR

James L. North
President

1600 Weston Parkway
New City, NL 33545

(505) 555-0077
james@superstar.corp

About Paper Color:
You are not restricted to
using matching paper for
all elements. The 3 pieces
here make a nice "mix and
match" solution for paper.

SUPERSTAR

1600 Weston Parkway
New City, NL 33545

The curve came from
software called TypeStyler.

1600 Weston Parkway
New City, NL 33545
(505) 555-0077

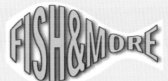

No logo? No problem. This fish shape was created in TypeStyler in about a minute or so. If you don't have this program, you might want to consider adding it to your array of tools.

1600 Weston Parkway • New City, NL 3354

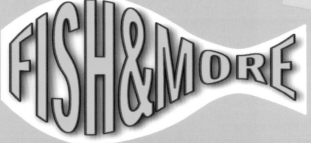

James L. North • President • (505) 555-0077

Note the unusual position of the type on the letterhead and envelope. Keep your mind open to unusual positions. In this case, the fish appears to be about to swallow the type. Neat.

1600 Weston Parkway
New City, NL 33545

The fish shape came from software called TypeStyler.

Dream Cars

1600 Weston Parkway
New City, NL 33545
(505) 555-0077
www.dreamcars.corp

No logo? No problem. A firm that restores vintage cars doesn't need a logo. Using a font that is reminiscent of the 1953 Chevy Bel Air is all you need.

Dream Cars

James L. North
President

1600 Weston Parkway
New City, NL 33545

(505) 555-0077
james@north.corp

Extra Pizazz: Get a real chrome look for the type by going into PhotoShop and using the "Bevel Boss" Feature of Eye Candy 4000.

Dream Cars

1600 Weston Parkway
New City, NL 33545

Dream Cars

Font: Americana Dreams
Source: flashfonts.com

Flatwoods Kindergarten

Flatwoods Kindergarten

James L. North
President

1600 Weston Parkway • New City, NL 33545
(505) 555-0077 • james@flatwoods.corp

When you don't have a logo to work with, look around the business for visual images that might let you use an all-type solution. Here, the ubiquitous "how to write the alphabet" is used as the dominant image for a kindergarten.

Flatwoods Kindergarten
1600 Weston Parkway • New City, NL 33545

1600 Weston Parkway • New City, NL 33545 • (

Font: School Oblique Lined
Source: studio.agfamonotype.com

Humpty Dumpty

Humpty Dumpty

1600 Weston Parkway
New City, NL 33545

James L. North
President

(505) 555-0077
james@humpty.corp

The type is big and bold and, yes, it's whimsical. When you don't have a logo, open your mind to the many possibilities of type.

Humpty Dumpty

1600 Weston Parkway
New City, NL 33545

Font: Spumoni LP
Source: studio.agfamonotype.com

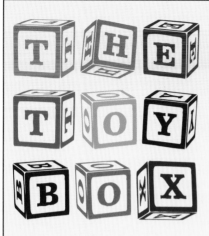

7600 Weston Parkway
New City, NL 33545

(505) 555-0077
www.toybox.corp

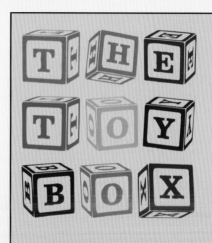

7600 Weston Parkway
New City, NL 33545

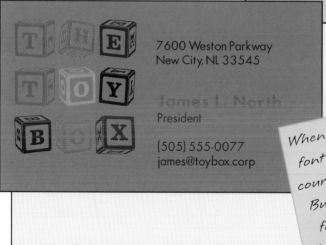

7600 Weston Parkway
New City, NL 33545

James L. North
President

(505) 555-0077
james@toybox.corp

When you see this name, and then the font that was used, you say, "Well, of course, that's the right font. And it is. But to get there, you have to LOOK for the font you need. A great font book is *The Big Book of 5,000 Fonts*. You'll see the type in use, and also where to get them.

Font: ToyBox Blocks
Source: P22.com

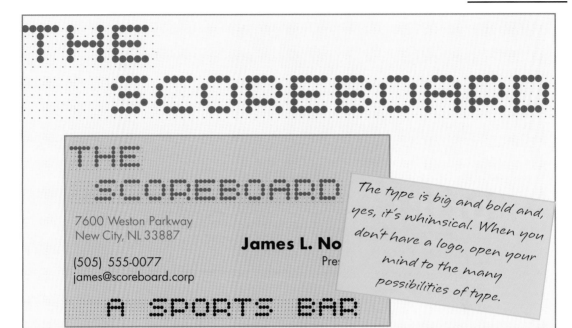

THE SCOREBOARD

THE SCOREBOARD

7600 Weston Parkway
New City, NL 33887

(505) 555-0077
james@scoreboard.corp

James L. No
Pres

A SPORTS BAR

The type is big and bold and, yes, it's whimsical. When you don't have a logo, open your mind to the many possibilities of type.

THE SCOREBOARD

7600 Weston Parkway
New City, NL 33545

A SPORTS BAR

7600 Weston Parkway • New City, NL 33545 • (505) 555-0077 • www.scoreboard.corp

A SPORTS BAR

Font: Skannerz
Source: synfonts.com

BLACK
BOOK

New City, NL 33545

Exclusive.
Private.
No phone number.

BLACK
BOOK

The idea of "exclusive" can be enhanced by an unlisted address. Note that the post office can return mail to you with only a 9-digit zip code. This is Las Vegas, "what happens here, stays here" brought to cards and envelopes.

BLACK
BOOK

33545-2150

So exclusive and private, even our address is unlisted.

Font: Recycle Alternate Reverse
Source: aerotype.com

OUTPATIENT CLINIC OF RATON

7600 Weston Parkway
New City, NL 33545

(505) 555-0077
www.getwell.corp

OUTPATIENT CLINIC OF RATON

7600 Weston Parkway
New City, NL 33887

There are hundreds of fonts that go beyond the ordinary, so when you have no logo and want to make a powerful visual statement, that's a good place to start.

OUTPATIENT CLINIC OF RATON

James L. North
President
james@getwell.corp

7600 Weston Parkway
New City, NL 33545
(505) 555-0077

Font: Ouch
Source: studio.agfamonotype.com

SURFBOARD CITY

1600 Weston Parkway
New City, NL 33545

(505) 555-0077
james@surfboard.corp

1600 Weston Parkway
New City, NL 33545

Got a surfboard shop? Then your font should look like a surfboard. This is just one of the many fonts that are highly specialized; they can go a long way toward creating a very distinctive look.

1600 Weston Parkway
New City, NL 33545

Font: Jackrabbit's Bar & Grill
Source: synfonts.com

Comic Books Etc.

1600 Weston Parkway
New City, NL 33887

(505) 555-0077
www.comics.corp

Comic Books Etc.

James L. North

1600 Weston Parkway
New City, NL 33545

(505) 555-0077
www.comics.corp

Using a "comic book" font immediately creates a fun feeling. Note how the envelope uses a variation of the card design. Envelopes are difficult to cover 100% with ink (not to mention the fact that an address must go there. Also note that the bottom of the envelope has space where the Post Office will imprint a bar code for faster delivery.

Comic Books Etc.

1600 Weston Parkway
New City, NL 33545

Font: Comicrazy—Italic

Source: comicbookfonts.com

Happy Collectibles

1600 Weston Parkway • New City, NL 33545 • (505) 555-0077

Happy Collectibles

1600 Weston Parkway
New City, NL 33545

There's no logo here, but the images are strong. The icons at the bottom are actually a font. The idea of many old collectibles is reinforced by the string of items across the page.

Happy Collectibles

James L. North
President

1600 Weston Parkway • New City, NL 33545 • (505) 555-0077

1600 Weston Parkway • New City, NL 33545 • (505) 555-0077

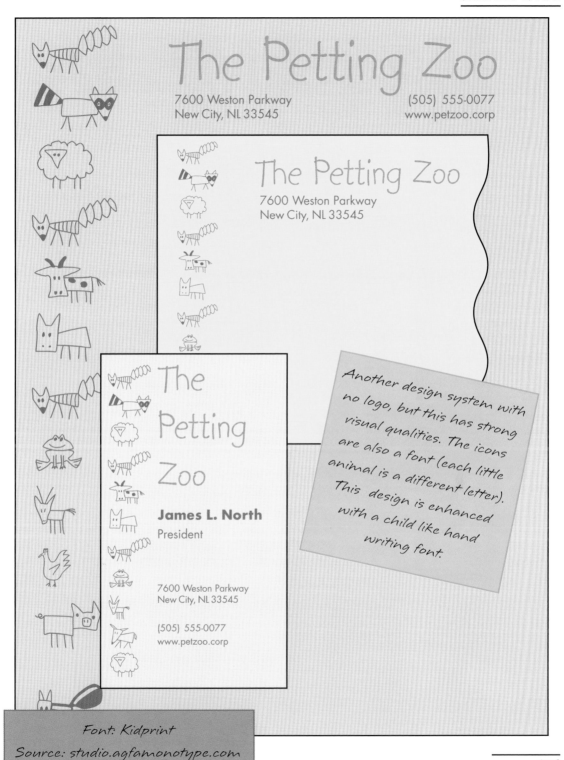

The Petting Zoo

7600 Weston Parkway
New City, NL 33545

(505) 555-0077
www.petzoo.corp

The Petting Zoo

7600 Weston Parkway
New City, NL 33545

The Petting Zoo

James L. North

President

7600 Weston Parkway
New City, NL 33545

(505) 555-0077
www.petzoo.corp

Another design system with no logo, but this has strong visual qualities. The icons are also a font (each little animal is a different letter). This design is enhanced with a child like hand writing font.

Font: Kidprint
Source: studio.agfamonotype.com

The Center for Mass Media

7600 Weston Parkway
New City, NL 33545

(505) 555-0077
www.massmedia.corp

Here's another font that is highly appropriate for a special organization. When you don't have a good logo to work with, think TYPE. And find one that's just right.

The Center for Mass Media

7600 Weston Parkway
New City, NL 33545

The Center for Mass Media

James L. North
President

7600 Weston Parkway
New City, NL 33545

(505) 555-0077
james@north.corp

Font: ANGRY
Source: 2Rebels.com

PLASTIC

7600 Weston Parkway
New City, NL 33545
(505) 555-0077
james@plasticthings.corp

THINGS

This identity has the look of plastic letters on a message board. Perfect solution for a plastics firm. Take the time to become familiar with the many fonts available. **(The Big Book of 5,000 Fonts** is a great source.)

PLASTIC
THINGS

7600 Weston Parkway
New City, NL 33545

PLASTIC
THINGS

7600 Weston Parkway
New City, NL 33545
(505) 555-0077
james@plasticthings.corp

James L. North
President

Font: PlasticMan
Source: 2Rebels.com

Kid Stuff

7600 Weston Parkway
New City, NL 33545
(505) 555-0077
www.kidstuff.corp

This business that deals with kid stuff uses a font that is very appealing to kids.

Kid Stuff

7600 Weston Parkway
New City, NL 33545

Kid Stuff

James L. North
President

7600 Weston Parkway
New City, NL 33545
(505) 555-0077
james@plasticthings.corp

Font: Giddyup
Source: studio.agfamonotype.com

Monet
Art Gallery

7600 Weston Parkway
New City, NL 33545
(505) 555-0077
www.monet.corp

Monet
Art Gallery

7600 Weston Parkway
New City, NL 33545

This font is based on the handwriting of the artist Monet. Note how the name on the business card uses the same Monet handwriting font.

Monet
Art Gallery

7600 Weston Parkway
New City, NL 33545
(505) 555-0077
james@monet.corp

James L. North
President

Font: Monet Regular
Source: p22.com

Laffalotts

7600 Weston Parkway
New City, NL 33545
(505) 555-0077
www.laffalots.corp

Laffalott

7600 Weston Parkway
New City, NL 33545

The type here is unusual, but it is enhanced by having 4 different colors used, just out of register, to add visual appeal. The icons at the bottom of the page are a font, one of a collection called Mini-Pics.

Laffalotts

James L. North
President

7600 Weston Parkway
New City, NL 33545
(505) 555-0077
james@laffalots.corp

Font: Curlz MT
Source: studio.agfamonotype.com

The Aztec Collection

7600 Weston Parkway New City, NL 33545 (505) 555-0077 www.aztec.corp

The Aztec Collection

7600 Weston Parkway
New City, NL 33545

A distinctive handwriting font adds to this design for a collection of Aztec items. The graphics at the bottom of the page are from a mini-pic font.

The Aztec Collection

James L. North
President

(505) 555-0077
james@north.corp

7600 Weston Parkway
New City, NL 33545

Font: Cezanne Regular
Source: P22.com

Open your mind to unusual placements of the elements on the letterhead set. Here, we have used the main elements at the lower left corner, not the usual top of the page standard.

THE TOY BOX

7600 Weston Parkway New City, NL 33545

Remember to leave this space open.
The post office puts bar codes at the bottom of envelopes.

THE TOY BOX

THE TOY BOX

James L. North
President

7600 Weston Parkway
New City, NL 33545

(505) 555-0077
james@thetoybox.corp

7600 Weston Parkway • New City, NL 33545 • (505) 555-0077

Font: Woodcut
Source: P22.com

ABCDEFG
HIJKLMN
OPQRStU
VWXYZ
@abcdefg
hijklmn
opqrst
vwxy

FONT INFO
For internet-related companies, this font may be a good design solution. It's called Arrobatheraphy,
Source: DaFont.com

Grungi Fonts

7600 Weston Parkway
New City, NL 33545
(505) 555-0077
www.grungi.corp

Design Hint:
When you use an extreme font,
use extreme colors as well.

Grungi Fonts

7600 Weston Parkway
New City, NL 33545

Grungi Fonts

James L. North
President

7600 Weston Parkway
New City, NL 33545
(505) 555-0077
james@grungi.corp

Font: KO—dirty
Source: 2Rebels.com

HALLOWEEN COSTUMES

7600 Weston Parkway
New City, NL 33545
(505) 555-0077

HALLOWEEN COSTUMES

7600 Weston Parkway
New City, NL 33545

Sometimes, good design is simply a matter of the right font and the right color. The font, Frostbite, available from ComicCraft, is perfect for a Halloween store. And the colors...chose themselves.

HALLOWEEN COSTOMES

James L. North
President

7600 Weston Parkway
New City, NL 33545
(505) 555-0077

Font: Frostbite
Source: comicbookfonts.com

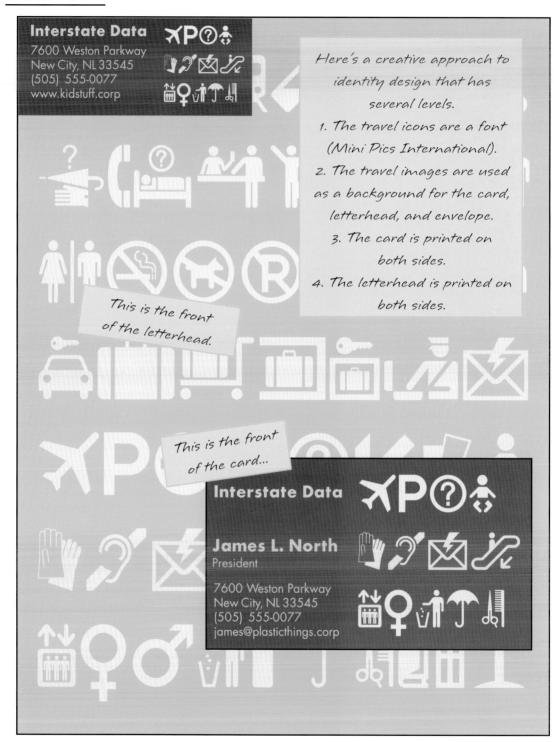

Interstate Data

7600 Weston Parkway
New City, NL 33545
(505) 555-0077
www.kidstuff.corp

Here's a creative approach to
identity design that has
several levels.
1. The travel icons are a font
(Mini Pics International).
2. The travel images are used
as a background for the card,
letterhead, and envelope.
3. The card is printed on
both sides.
4. The letterhead is printed on
both sides.

This is the front
of the letterhead.

This is the front
of the card...

Interstate Data

James L. North
President

7600 Weston Parkway
New City, NL 33545
(505) 555-0077
james@plasticthings.corp

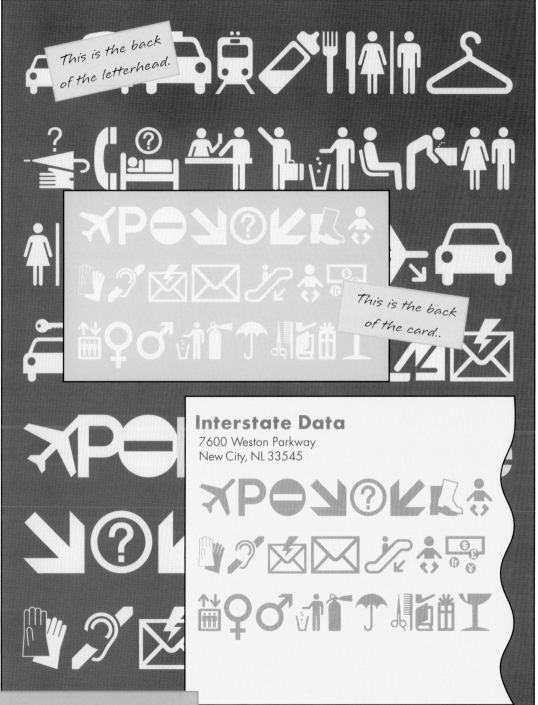

This is the back of the letterhead.

This is the back of the card..

Interstate Data
7600 Weston Parkway
New City, NL 33545

Font: MiniPics International
Source: Image Club

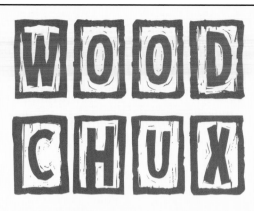

7600 Weston Parkway
New City, NL 33957
(505) 555-0077

7600 Weston Parkway
New City, NL 33957

James L. North
President

(505) 555-0077
james@woodchux.corp

7600 Weston Parkway
New City, NL 33957

Font: Digital Woodcuts Open
Source: itcfonts.com

WOOD
CHUX

7600 Weston Parkway
New City, NL 33957
(505) 555-0077

WOOD
CHUX

7600 Weston Parkway
New City, NL 33957

Mix and Match.
With Fonts

Many fonts have several
varieties within the family.
Some of these can be used
very well to create "mix &
match" with type, as well
as with color and paper.
On this page and the
preceding page are good
examples of this technique.

WOOD
CHUX

7600 Weston Parkway
New City, NL 33957

James L. North
President

(505) 555-0077
james@woodchux.corp

1600 Weston Parkway
New City, NL 33957
(505) 555-0077

Sometimes you'll "just know" when you've found the right font. This particular font will greatly enhance the clients corporate image.

7600 Weston Parkway
New City, NL 33957

James L. North
President

(505) 555-0077
james@taco2.ccorp

1600 Weston Parkway
New City, NL 33957
(505) 555-0077

Font: Bermuda LP Squiggle
Source: studio.agfamonotype.com

The
Typewrtiter
Museum

7600 Weston Parkway
New City, NL 33957
(505) 555-0077

Here's the Just Right font for this client.
Next, think if there are any other type elements that can add to the museum....
(see bottom)

The
Typewrtiter
Museum

7600 Weston Parkway
New City, NL 33957

James L. North
President

(505) 555-0077
james@north.corp

The quick brown fox
jumped over the lazy
bleeping dog. asdf jk

The
Typewrtiter
Museum

7600 Weston Parkway
New City, NL 33957

The quick brown fox jumped over the
lazy bleeping dog. asdf jkl; The quick

The quick brown fox jumped over the lazy
bleeping dog. asdf jkl; The quick brown fox

Font: Bighead—Bold
Source: typeart.com

When you have found an interesting font, check for all the variations inside.

Here, the standard "solid" font has one look, while the outline variety has a different image, and finally, the open font looks even different.

Some font families have as many as 30 variations. Check them out.

FONT LESSON

SOLID TYPE

OUTLINE FONT

OPEN JUST 4U

Font: Destroyer

Source: comicbookfonts.com

YOO, TOO

7600 Weston Parkway New City, NL 33957 (505) 555-0077

YOO, TOO

7600 Weston Parkway New City, NL 33957 (505) 555-0077

James L. North
President

YOO, TOO

7600 Weston Parkway New City, NL 33957

Find the "Just Right" font.
A large percentage of your
clients will have a product
or service that allows you
to find a font that will
greatly enhance their
corporate image.
The fonts are out there.
Take the time to FIND
the "Just Right" one.

Font: Bithead—Byte
Source: comicbookfonts.com

Dracula, Inc.

7600 Weston Parkway
New City, NL 33957
(505) 555-0077

Dracula, Inc.

James L. North
President

7600 Weston Parkway
New City, NL 33957
(505) 555-0077

Dracula, Inc.

7600 Weston Parkway
New City, NL 33957
(505) 555-0077

TO:

Here's another "Just Right" font for this client. The lack of a logo should not be seen as a negative, but as opportunity to use a very creative font. Color changes add to the overall look of the stationary set.

Font: Divine Right
Source: comicbookfonts.com

No Logo?
Use Stock Art
& Photographs

In your ideal business card assignment, your client will A) already have a world-class logo, or B) let you design a world-class logo. Right.

If there's no logo, and the job doesn't include a new one, then what?

Stock art or photography is a good source for exciting visuals. There are tens of thousands of good images out there, waiting for you to choose the "Just Right" one...and then apply it to the project in a way that would make your granny proud of you.

The upside of using stock images: there are some really great ones, and most of them are reasonably priced (especially for royalty-free use.)

The downside of stock images: 1) You don't have ownership, the way a client would own a normal logo. 2) The cost can be more than you want, especially if they're royalty based. Be sure to get royalty-free images.

With those cautions, let's venture into a world of stock images and see what kind of things we can create.

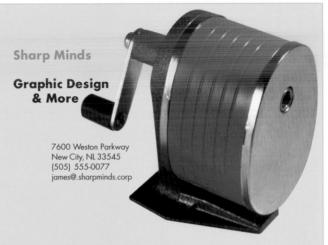

Sharp Minds

**Graphic Design
& More**

7600 Weston Parkway
New City, NL 33545
(505) 555-0077
james@.sharpminds.corp

USING STOCK IMAGES

The creative process: I have found that flipping through (the right) catalogs or web sites with royalty-free art is a great way to generate ideas for your next project. By doing this, you might come up with solutions that you would otherwise never achieve. Take this page. The name "Sharp Minds" is a good starting point to go into a stock photoart search engine and see what appears. Play with the individual words "sharp" and "mind" separately. See what you get. Sharp revealed the pencil sharpener, and since the company is in the visual arts, the pencil sharpener is a part of the creation process. Thus, the pencil sharpener becomes the corporate icon for Sharp Minds.

Sharp Minds

**Graphic Design
& More**

James L. North
President

7600 Weston Parkway
New City, NL 33545
(505) 555-0077
james@.sharpminds.corp

fotosearch.com/image-club

North Associates

7600 Weston Parkway
New City, NL 33545
(505) 555-0077
www.north.corp

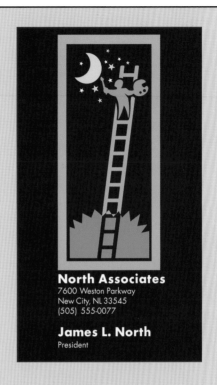

North Associates
7600 Weston Parkway
New City, NL 33545
(505) 555-0077

James L. North
President

North Associates

7600 Weston Parkway
New City, NL 33545

Using stock art doesn't have to mean that your work looks "stock." Today, there is a great deal of quality work available. Just go to your favorite search engine and type in "stock art" and see what you find.

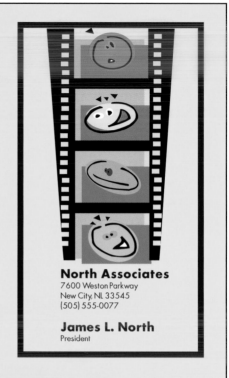

North Associates
7600 Weston Parkway
New City, NL 33545
(505) 555-0077

James L. North
President

Who'd ever guess that lively identity set is what used to be called "clip art?" This is striking and designed to grab attention.

North Associates
7600 Weston Parkway
New City, NL 33545

fotosearch.com/image-club

North Associates
7600 Weston Parkway
New City, NL 33545
(505) 555-0077

Things for Babies

North Associates
7600 Weston Parkway
New City, NL 33545
(505) 555-0077

Things for Babies

James L. North
President

Always be on the lookout for clever ideas that make the business stand out...such as pink and blue business cards.

North Associates
7600 Weston Parkway
New City, NL 33545

Things for Babies

With a business that sells "things for babies," a quick look through stock art came up with this diaper pin. (I know, they don't use pins anymore, but it's kind of symbolic.)

North Associates
7600 Weston Parkway
New City, NL 33545
(505) 555-0077

Things for Babies

James L. North
President

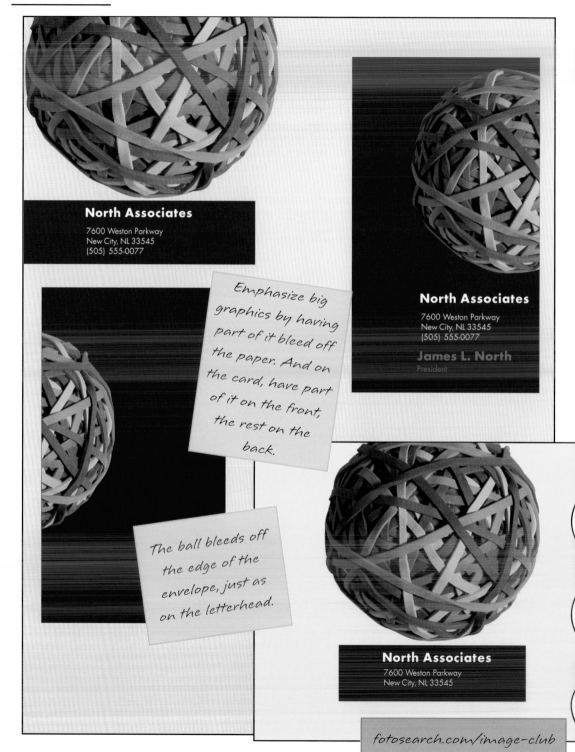

North Associates

7600 Weston Parkway
New City, NL 33545
(505) 555-0077

North Associates

7600 Weston Parkway
New City, NL 33545
(505) 555-0077

James L. North
President

Emphasize big graphics by having part of it bleed off the paper. And on the card, have part of it on the front, the rest on the back.

The ball bleeds off the edge of the envelope, just as on the letterhead.

North Associates
7600 Weston Parkway
New City, NL 33545

fotosearch.com/image-club

134

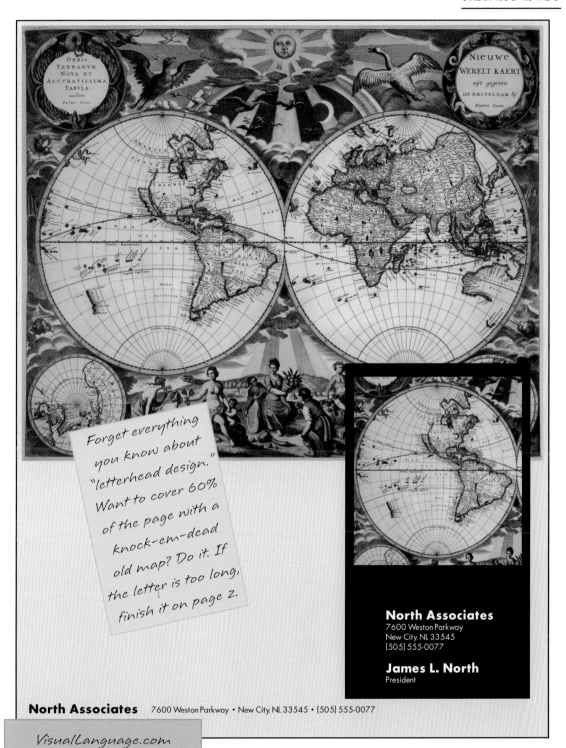

Forget everything you know about "letterhead design." Want to cover 60% of the page with a knock-em-dead old map? Do it. If the letter is too long, finish it on page 2.

North Associates
7600 Weston Parkway
New City, NL 33545
(505) 555-0077

James L. North
President

North Associates 7600 Weston Parkway • New City, NL 33545 • (505) 555-0077

VisualLanguage.com

North Associates
7600 Weston Parkway
New City, NL 33545
(505) 555-0077

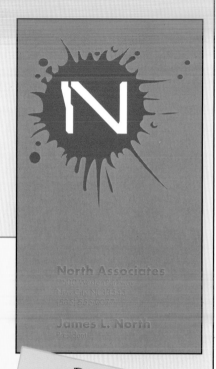

North Associates
7600 Weston Parkway
New City, NL 33545
(505) 555-0077

James L. North
President

North Associates
7600 Weston Parkway
New City, NL 33545
(505) 555-0077

Remember this sentence: <u>Know your resources.</u> In your spare time, check out the many sources of stock art. This neat graphic is just one of many that is found showing initials on interesting backgrounds.

Art: CapTiles
3G Services Inc. Edmonds, WA

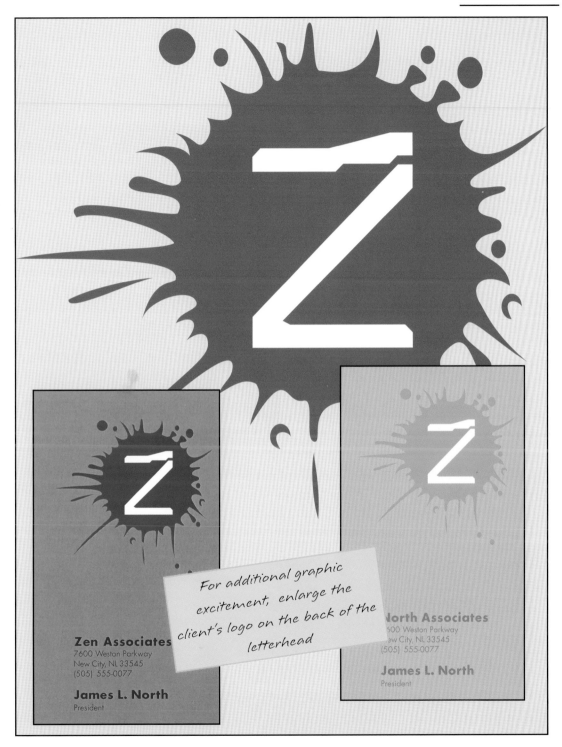

Zen Associates
7600 Weston Parkway
New City, NL 33545
(505) 555-0077

James L. North
President

For additional graphic excitement, enlarge the client's logo on the back of the letterhead

North Associates
500 Weston Parkway
New City, NL 33545
(505) 555-0077

James L. North
President

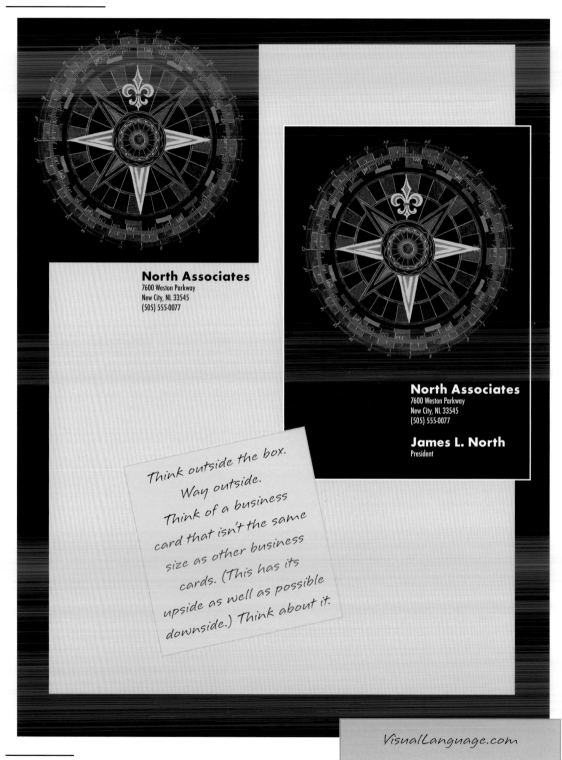

North Associates
7600 Weston Parkway
New City, NL 33545
(505) 555-0077

North Associates
7600 Weston Parkway
New City, NL 33545
(505) 555-0077

James L. North
President

*Think outside the box.
Way outside.
Think of a business
card that isn't the same
size as other business
cards. (This has its
upside as well as possible
downside.) Think about it.*

VisualLanguage.com

North Associates
7600 Weston Parkway
New City, NL 33545
(505) 555-0077

North Associates
7600 Weston Parkway
New City, NL 33545
(505) 555-0077

James L. North
President

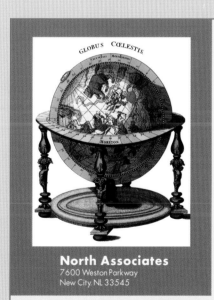

North Associates
7600 Weston Parkway
New City, NL 33545

There are some very good sources for old maps, globes, etc. For a company in a travel-related business, this can greatly enhance the corpoarte image.

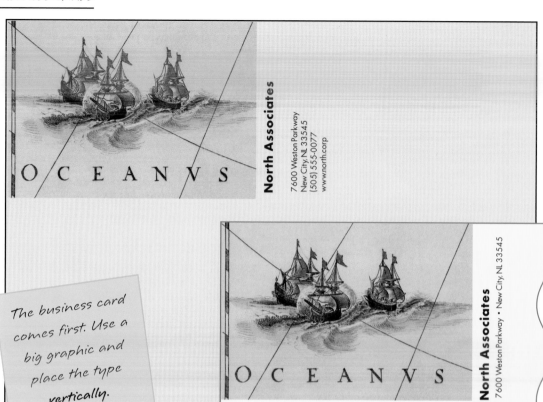

The business card comes first. Use a big graphic and place the type *vertically*.

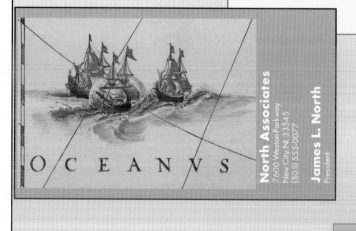

VisualLanguage.com

Changing Stock Art to make it work for you

If you find the "almost right" art, except it's black and white, think color. Here's what you can do with a little imagination.

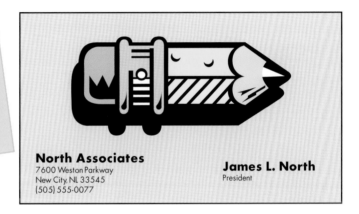

North Associates
7600 Weston Parkway
New City, NL 33545
(505) 555-0077

James L. North
President

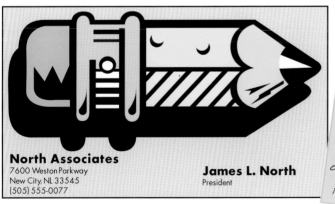

North Associates
7600 Weston Parkway
New City, NL 33545
(505) 555-0077

James L. North
President

Make the artwork larger and you can use it on the back... or as a very dominant feature for the front.

fotosearch.com/image-club

North Associates
7600 Weston Parkway
New City, NL 33545
(505) 555-0077

North Associates
7600 Weston Parkway
New City, NL 33545
(505) 555-0077

James L. North
President

We're musicians, and
we want the world to
know. So the card has
a big music thing on it.
And the letterhead has
only 40% of its area
available for typing.
Out of the box
thinking.

aridi.com

North Associates

7600 Weston Parkway
New City, NL 33545
(505) 555-0077
www.north.corp

No logo...but you find this neat umbrella graphic. You use it as an extra device on the letterhead, on the back of the card, even larger on the front.

Conventional wisdom says "center the umbrella." Well, we like to have conventional wisdom for lunch. Put it off center and make it look much bolder.

North Associates
7600 Weston Parkway
New City, NL 33545
(505) 555-0077

James L. North
President

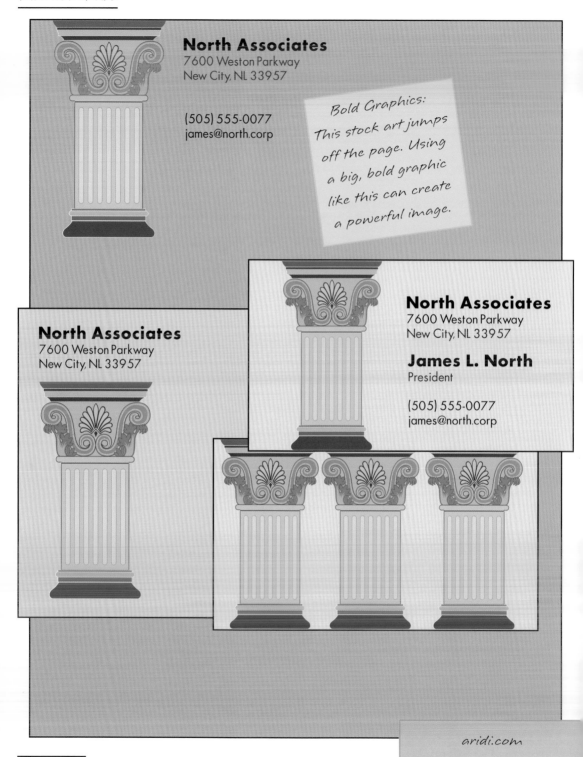

North Associates
7600 Weston Parkway
New City, NL 33957

(505) 555-0077
james@north.corp

*Bold Graphics:
This stock art jumps
off the page. Using
a big, bold graphic
like this can create
a powerful image.*

North Associates
7600 Weston Parkway
New City, NL 33957

North Associates
7600 Weston Parkway
New City, NL 33957

James L. North
President

(505) 555-0077
james@north.corp

aridi.com

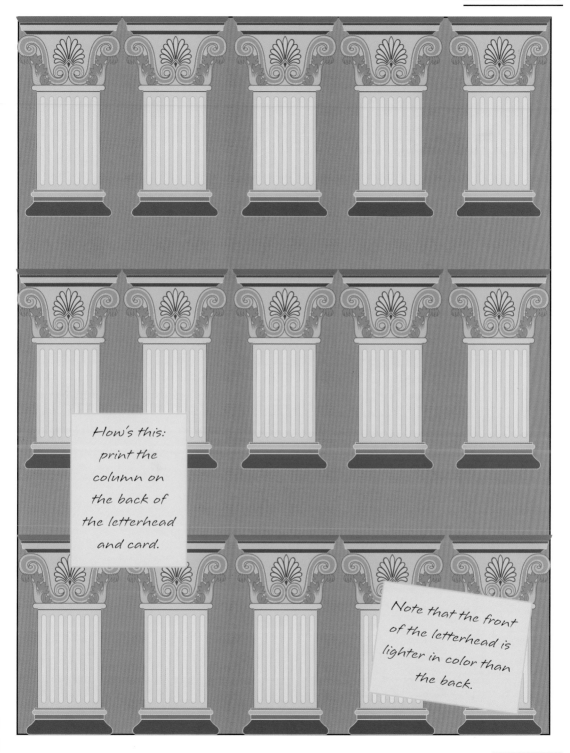

How's this: print the column on the back of the letterhead and card.

Note that the front of the letterhead is lighter in color than the back.

North Associates
7600 Weston Parkway
New City, NL 33545
(505) 555-0077

Multiply. Take a black
& white logo, turn it to
color, then place it all
over. It's on the back
of the card, and it's
strategically placed on
the letterhead so that
it does not disturb the
letter's content.

North Associates
7600 Weston Parkway
New City, NL 33545
(505) 555-0077

James L. North
President

ultimatesymbol.com

Rainbow Designs

7600 Weston Parkway
New City, NL 33545
e(505) 555-0077

Rainbow Designs
7600 Weston Parkway
New City, NL 33545
(505) 555-0077

James L. North
President

The small black logo at the top is conservative. But multiply, add color, enlarge, and bleed off the page. Quite an impact!

ultimatesymbol.com

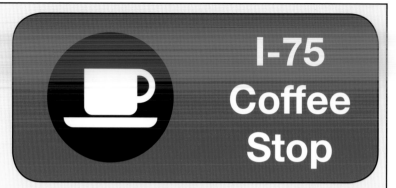

I-75 Coffee Shop
7600 Weston Parkway
New City, NL 33545
(505) 555-0077

James L. North
President

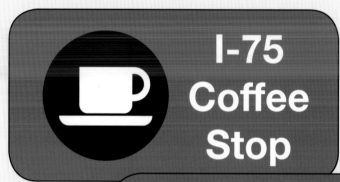

*The business card
is designed to resemble
an "Interstate Sign".
The back of the card has
all the details.*

I-75 Coffee Shop
7600 Weston Parkway
New City, NL 33545
(505) 555-0077

James L. North
President

ultimatesymbol.com

NOTE: Placing a
large image in the upper right
corner of the letterhead still
gives plenty of room for even
long letters.

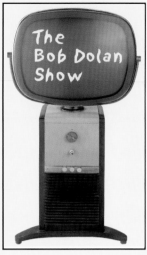

The Bob Dolan Show

7600 Weston Parkway
New City, NL 33545
(505) 555-0077

The card back is
completely covered
by the client's logo
or image. The card
front contains
all pertinent
information.

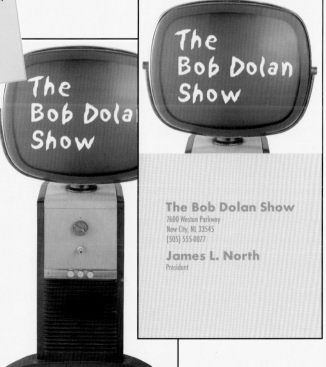

The Bob Dolan Show
7600 Weston Parkway
New City, NL 33545
(505) 555-0077

James L. North
President

Classic PIO

All Elvis, All the Time

North Associates

7600 Weston Parkway
New City, NL 33545
(505) 555-0077

Try using TWO clip art elements when you don't have a logo.

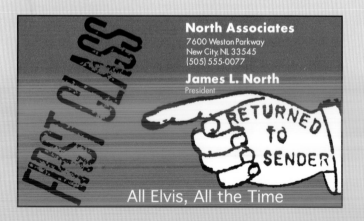

North Associates

7600 Weston Parkway
New City, NL 33545
(505) 555-0077

James L. North
President

All Elvis, All the Time

ultimatesymbol.com

North Associates
7600 Weston Parkway
New City, NL 33545
(505) 555-0077

James L. North
President

This clip art element is a strip of film. Perfect for a photographer. There are many great images available as stock art. Find them.

North Associates
7600 Weston Parkway
New City, NL 33545
(505) 555-0077

ultimatesymbol.com

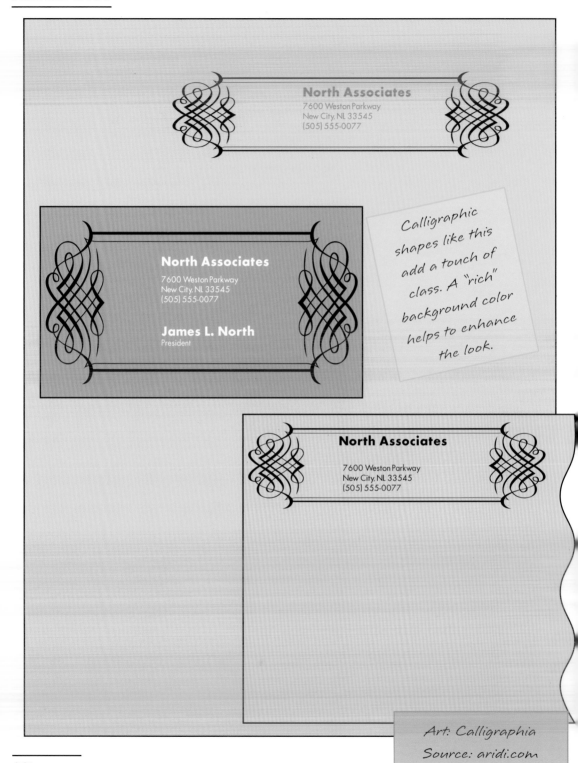

North Associates
7600 Weston Parkway
New City, NL 33545
(505) 555-0077

North Associates

7600 Weston Parkway
New City, NL 33545
(505) 555-0077

James L. North
President

Calligraphic shapes like this add a touch of class. A "rich" background color helps to enhance the look.

North Associates

7600 Weston Parkway
New City, NL 33545
(505) 555-0077

Art: Calligraphia
Source: aridi.com

North Associates
7600 Weston Parkway
New City, NL 33545
(505) 555-0077

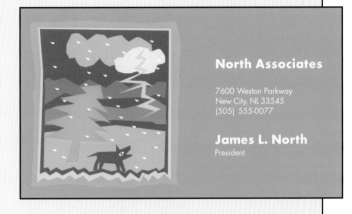

North Associates

7600 Weston Parkway
New City, NL 33545
(505) 555-0077

James L. North
President

Lots of stock art will be in color. You have the flexibility of using a complimentary color with the art. Having the type color match the art ties it all together.

North Associates
7600 Weston Parkway
New City, NL 33545
(505) 555-0077

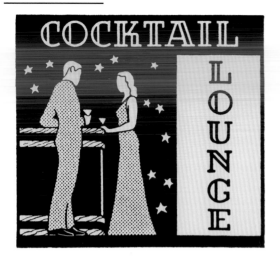

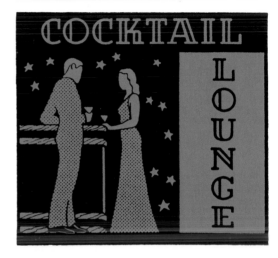

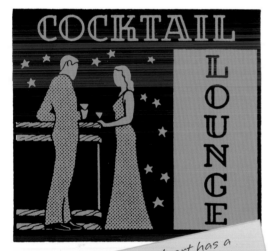

When your stock art has a transparent background, you can quickly change the look (and mood) of the piece by simply laying a color behind the art. Note how the last one uses multiple colors.

Art: Retro Ad Art

Source: AdGraphics, Bellingham, WA

Casaway Stables
7600 Weston Parkway
New City, NL 33545
(505) 555-0077

James L. North
President

Casaway Stables
7600 Weston Parkway
New City, NL 33545
(505) 555-0077

James L. North
President

Casaway Stables
7600 Weston Parkway
New City, NL 33545
(505) 555-0077

James L. North
President

You will find that many clip art systems have various styles of alphabet. Find the one that is just right for your client, and then design the card, envelope, and letterhead.

Art: CapTiles
Source: AdGraphics, Bellingham, WA

Egyptian Arts

7600 Weston Parkway
New City, NL 33545
(505) 555-0077

James L. North
President

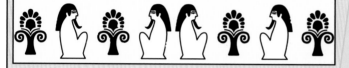

There are many sources of stock art that have an ethnic or cultural look. This elongated art is perfect for use at the bottom of a printed piece.

Egyptian Arts

7600 Weston Parkway
New City, NL 33545
(505) 555-0077

James L. North
President

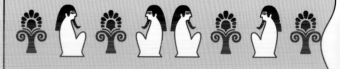

Egyptian Arts

7600 Weston Parkway
New City, NL 33545
(505) 555-0077

James L. North
President

fotosearch.com/image-club

North Associates

7600 Weston Parkway
New City, NL 33545
(505) 555-0077

When the art is just right, you can do a neat card with part of the image on the front and...

North Associates

7600 Weston Parkway
New City, NL 33545
(505) 555-0077

James L. North
President

...the other half on the back of the card.

North Associates

7600 Weston Parkway
New City, NL 33545
(505) 555-0077

North Associates
7600 Weston Parkway
New City, NL 33545
(505) 555-0077

North Associates
7600 Weston Parkway
New City, NL 33545
(505) 555-0077

James L. North
President

North Associates
7600 Weston Parkway
New City, NL 33545
(505) 555-0077

James L. North
President

Think about backgrounds. Here, we have the water and the sky as different colors.

The Purple Giraffe

7600 Weston Parkway
New City, NL 33545
(505) 555-0077

Never saw a purple giraffe.
I never hope to see one.
But I can tell you anyhow.
I'd rather see than flee one.

Look for interesting shapes. And don't let the color be a barrier. This black and white giraffe was changed to purple. Because we could.

The Purple Giraffe

7600 Weston Parkway
New City, NL 33545
(505) 555-0077

Never saw a purple giraffe.
I never hope to see one.
But I can tell you anyhow.
I'd rather see than flee one.

The Purple Giraffe

7600 Weston Parkway
New City, NL 33545
(505) 555-0077

Never saw a purple giraffe.
I never hope to see one.
But I can tell you anyhow.
I'd rather see than flee one.

fotosearch.com/image-club

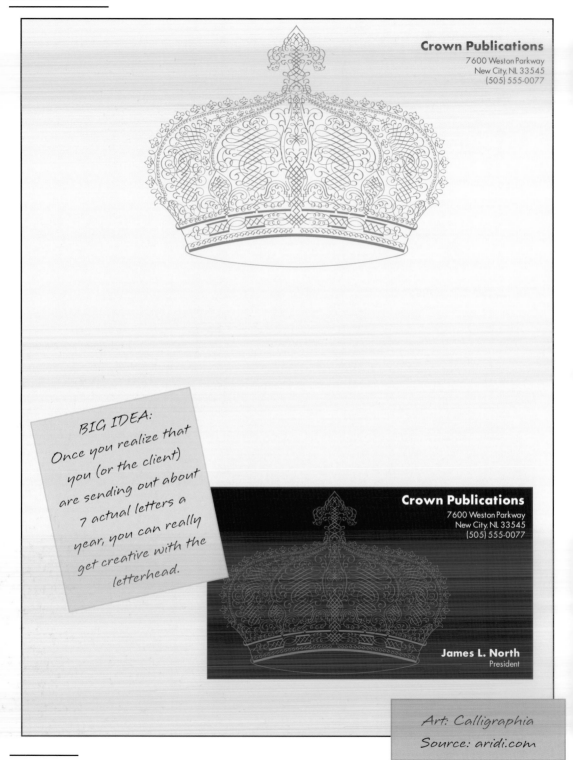

Crown Publications

7600 Weston Parkway
New City, NL 33545
(505) 555-0077

BIG IDEA:
Once you realize that you (or the client) are sending out about 7 actual letters a year, you can really get creative with the letterhead.

Crown Publications

7600 Weston Parkway
New City, NL 33545
(505) 555-0077

James L. North
President

Art: Calligraphia
Source: aridi.com

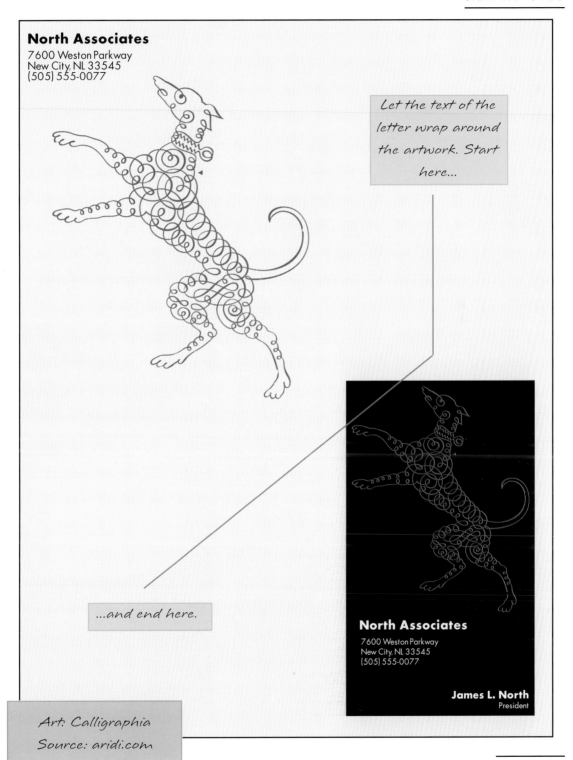

North Associates

7600 Weston Parkway
New City, NL 33545
(505) 555-0077

Let the text of the letter wrap around the artwork. Start here...

...and end here.

North Associates

7600 Weston Parkway
New City, NL 33545
(505) 555-0077

James L. North
President

Art: Calligraphia
Source: aridi.com

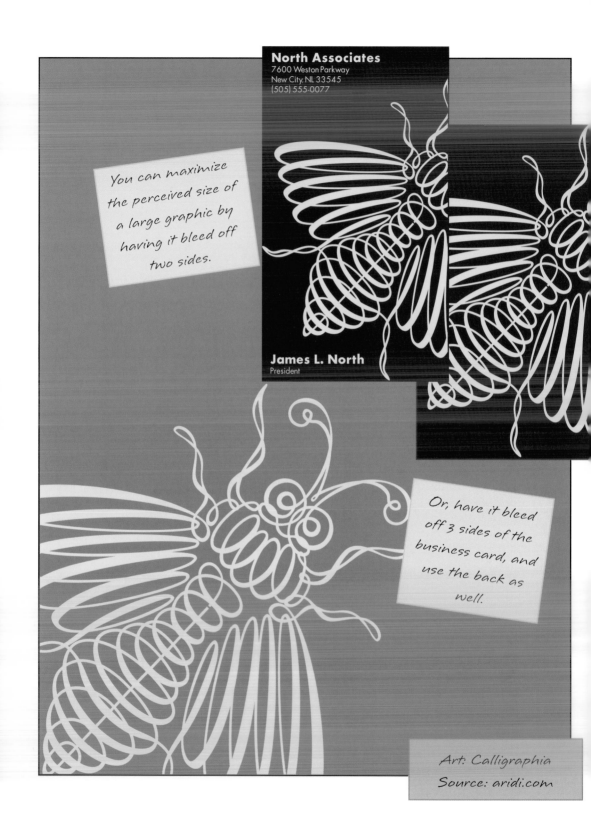

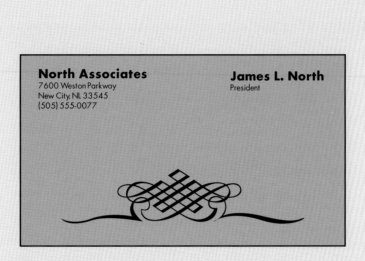

North Associates
7600 Weston Parkway
New City, NL 33545
(505) 555-0077

James L. North
President

North Associates
7600 Weston Parkway
New City, NL 33545
(505) 555-0077

Calligraphic icons can be used for a largy variety of businesses. Finding the right one, and using it creatively, can make a great identity system.

North Associates
7600 Weston Parkway

Art: Calligraphia
Source: aridi.com

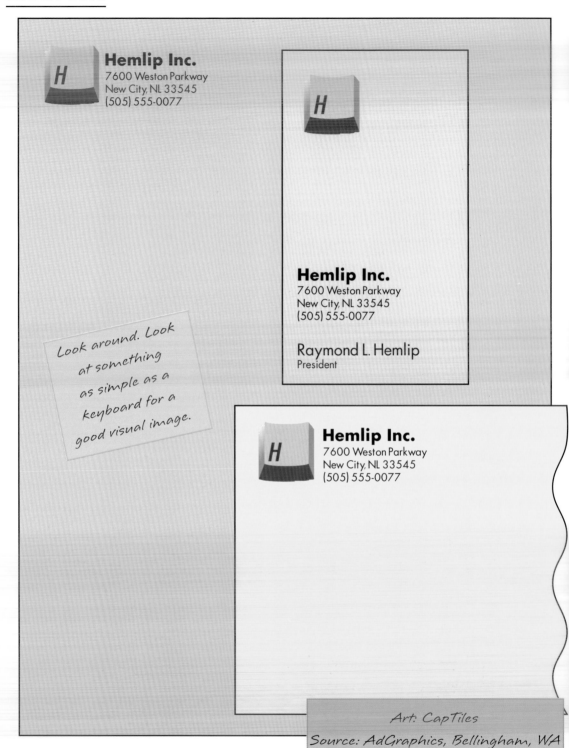

Hemlip Inc.
7600 Weston Parkway
New City, NL 33545
(505) 555-0077

Hemlip Inc.
7600 Weston Parkway
New City, NL 33545
(505) 555-0077

Raymond L. Hemlip
President

Look around. Look at something as simple as a keyboard for a good visual image.

Hemlip Inc.
7600 Weston Parkway
New City, NL 33545
(505) 555-0077

Art: CapTiles
Source: AdGraphics, Bellingham, WA

Think retro. Look to images from the recent past that might be a strong image for your client.

North Associates
7600 Weston Parkway
New City, NL 33545
(505) 555-0077

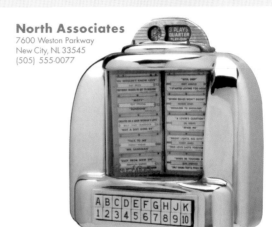

North Associates
7600 Weston Parkway
New City, NL 33545

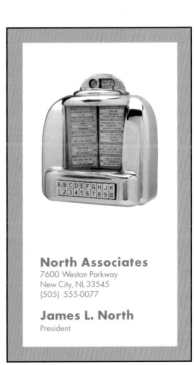

North Associates
7600 Weston Parkway
New City, NL 33545
(505) 555-0077

James L. North
President

*Art Source: Classic PIO Partners
Pasadena, CA*

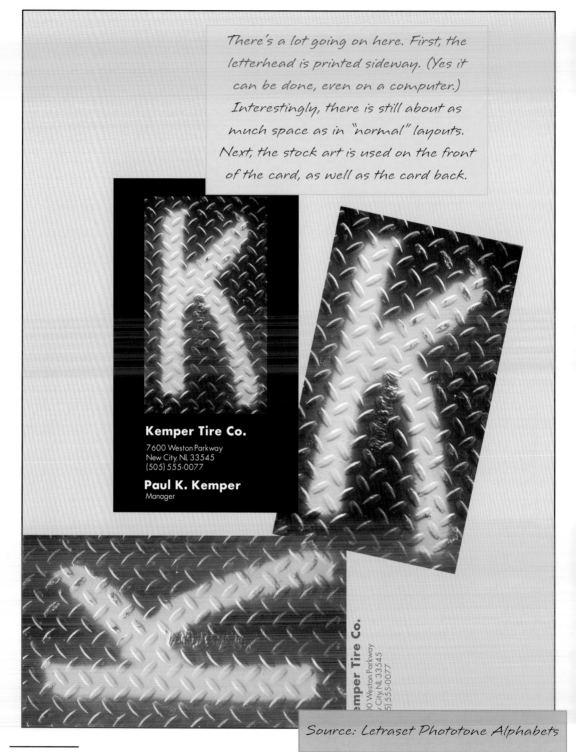

There's a lot going on here. First, the letterhead is printed sideway. (Yes it can be done, even on a computer.) Interestingly, there is still about as much space as in "normal" layouts. Next, the stock art is used on the front of the card, as well as the card back.

Kemper Tire Co.

7600 Weston Parkway
New City, NL 33545
(505) 555-0077

Paul K. Kemper
Manager

Kemper Tire Co.

7600 Weston Parkway
New City, NL 33545
(505) 555-0077

Source: Letraset Phototone Alphabets

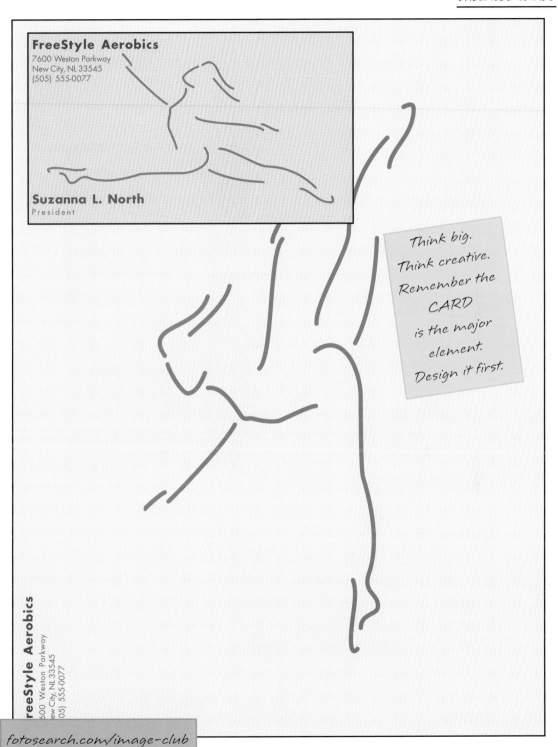

FreeStyle Aerobics
7600 Weston Parkway
New City, NL 33545
(505) 555-0077

Suzanna L. North
President

Think big.
Think creative.
Remember the
CARD
is the major
element.
Design it first.

FreeStyle Aerobics
7600 Weston Parkway
New City, NL 33545
(505) 555-0077

Mundt's Flowers
7600 Weston Parkway
New City, NL 33545
(505) 555-0077

Mundt's Flowers
7600 Weston Parkway
New City, NL 33545
(505) 555-0077

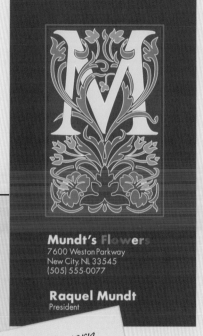

Mundt's Flowers
7600 Weston Parkway
New City, NL 33545
(505) 555-0077

Raquel Mundt
President

This flowery design is just one of the many initial styles available as stock art. Notice the different color type.

aridi.com

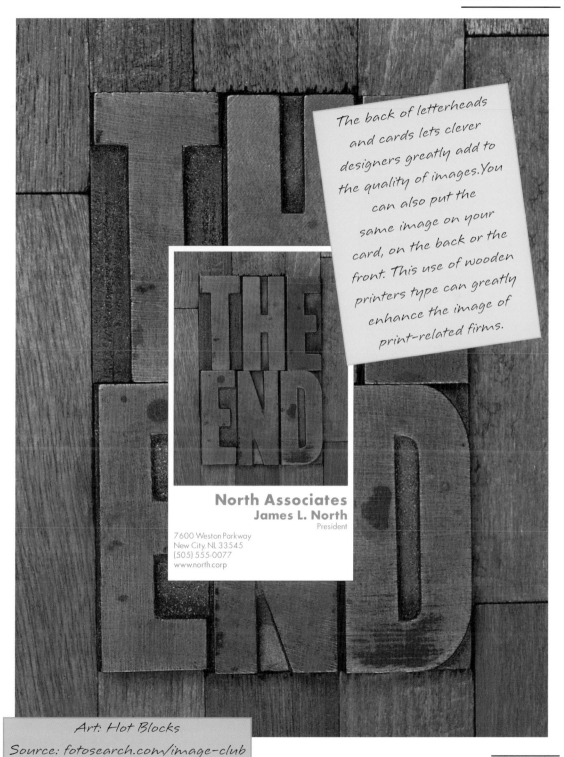

The back of letterheads and cards lets clever designers greatly add to the quality of images. You can also put the same image on your card, on the back or the front. This use of wooden printers type can greatly enhance the image of print-related firms.

North Associates
James L. North
President

7600 Weston Parkway
New City, NL 33545
(505) 555-0077
www.north.corp

Art: Hot Blocks
Source: fotosearch.com/image-club

No Logo?
No problem.
No time
(or budget)
for stock art?
Never fear.

Use

Creative

Layouts.

Swiss Cheese

7600 Weston Parkway
New City, NL 33545
(505) 555-0077

Think creative, Think about having actual holes in the paper to simulate Swiss cheese.

Swiss Cheese

7600 Weston Parkway
New City, NL 33545
(505) 555-0077

James L. North
President

Swiss Cheese

7600 Weston Parkway
New City, NL 33545

Yes, these are actual holes, punched through the paper.

North Associates

7600 Weston Parkway
New City, NL 33545
(505) 555-0077

Do something very different. Start with white paper (that's pretty common), but then, print solid colors on both sides of the paper. Do the same for letterheads and cards.

North Associates

7600 Weston Parkway
New City, NL 33545
(505) 555-0077

James L. North
President

Now here's where this gets interesting. The best way to do this is to use white ink. YES, there is white ink. It looks great on these darker colors.

North Associates
7600 Weston Parkway
New City, NL 33545
(505) 555-0077

North Associates
7600 Weston Parkway
New City, NL 33545
(505) 555-0077

Here is where the fun begins. Now, print the type on the back (which is even darker than the fronts). Use white ink, just like on the front. But here, print the type as a mirror image from the way it is seen on the front. This is a very distinctive visual image. You don't see this done often, and it's sure to get lots of comments.

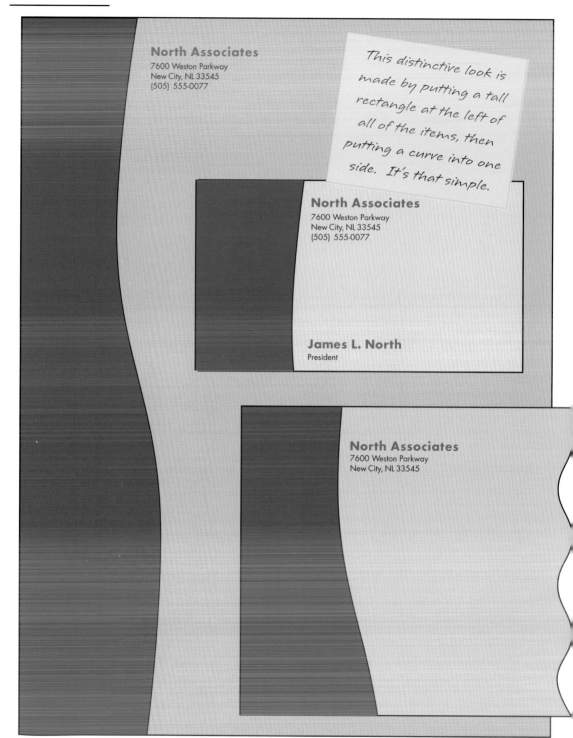

North Associates
7600 Weston Parkway
New City, NL 33545
(505) 555-0077

This distinctive look is made by putting a tall rectangle at the left of all of the items, then putting a curve into one side. It's that simple.

North Associates
7600 Weston Parkway
New City, NL 33545
(505) 555-0077

James L. North
President

North Associates
7600 Weston Parkway
New City, NL 33545

North Associates
7600 Weston Parkway
New City, NL 33545
(505) 555-0077

North Associates
7600 Weston Parkway
New City, NL 33545
(505) 555-0077

James L. North
President

North Associates
7600 Weston Parkway
New City, NL 33545
(505) 555-0077

Same look as the one at left, except there are two colors in the bar. This was made by blending. Almost all of the drawing programs have this feature.

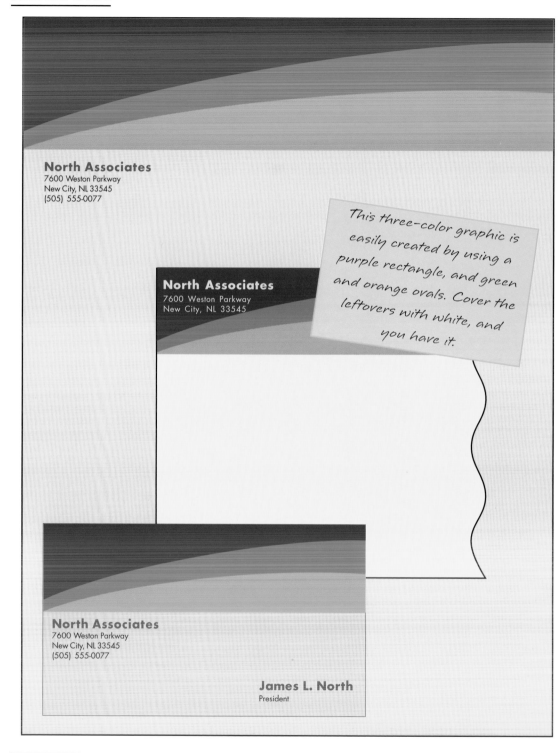

North Associates
7600 Weston Parkway
New City, NL 33545
(505) 555-0077

This three-color graphic is easily created by using a purple rectangle, and green and orange ovals. Cover the leftovers with white, and you have it.

North Associates
7600 Weston Parkway
New City, NL 33545

North Associates
7600 Weston Parkway
New City, NL 33545
(505) 555-0077

James L. North
President

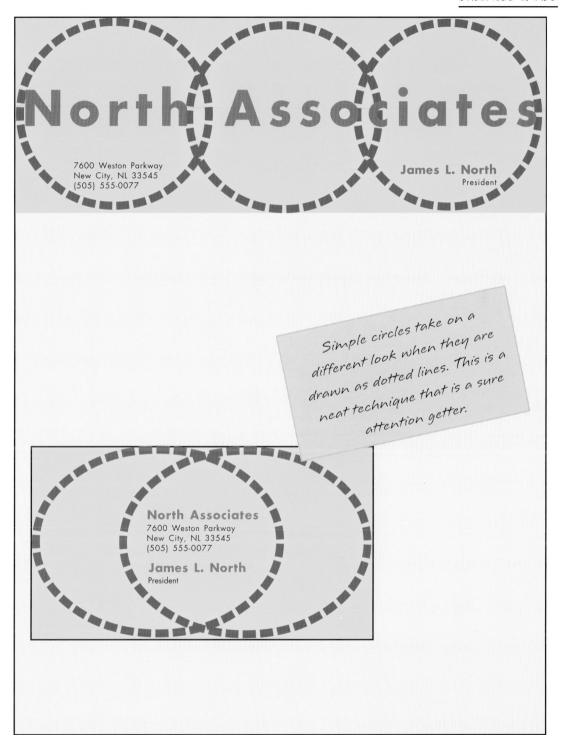

North Associates

7600 Weston Parkway
New City, NL 33545
(505) 555-0077

James L. North
President

Simple circles take on a different look when they are drawn as dotted lines. This is a neat technique that is a sure attention getter.

North Associates
7600 Weston Parkway
New City, NL 33545
(505) 555-0077

James L. North
President

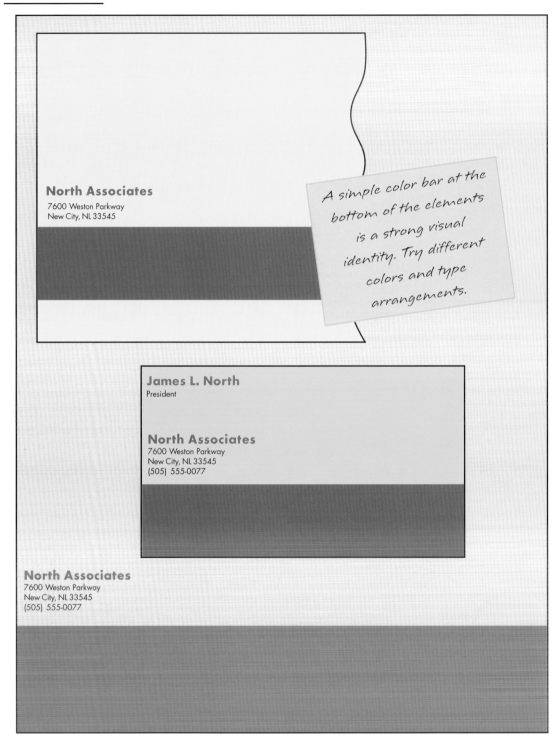

North Associates
7600 Weston Parkway
New City, NL 33545

A simple color bar at the bottom of the elements is a strong visual identity. Try different colors and type arrangements.

James L. North
President

North Associates
7600 Weston Parkway
New City, NL 33545
(505) 555-0077

North Associates
7600 Weston Parkway
New City, NL 33545
(505) 555-0077

This unusual shape has been applied to the bottom of the letterhead. Is this a huge circle, or what? The interest is inherent, and the focal point at the bottom is where the company name goes.

James L. North
President

North Associates
7600 Weston Parkway
New City, NL 33545
(505) 555-0077

North Associates
7600 Weston Parkway
New City, NL 33545
(505) 555-0077

North Associates

7600 Weston Parkway
New City, NL 33545
(505) 555-0077

Jump off the page with bright colors and blending. It's easy to do. Most all of the drawing programs have the feature. Make sure you have enough space on the letterhead for type to fit.

North Associates

7600 Weston Parkway
New City, NL 33545
(505) 555-0077

James L. North
President

SunBurst Media

7600 Weston Parkway
New City, NL 33545
(505) 555-0077

This system has the same concept, except the blending starts at the center and radiates outward.

Sunburst Media

7600 Weston Parkway
New City, NL 33545
(505) 555-0077

James L. North
President

North Associates
7600 Weston Parkway
New City, NL 33545
(505) 555-0077

North Associates
7600 Weston Parkway
New City, NL 33545
(505) 555-0077

James L. North
President

Rectangular borders for each of the items, but with a different design twist. Most drawing programs have a paintbrush which will let you customize the texture of the border.

North Associates
7600 Weston Parkway
New City, NL 33545

North Associates
7600 Weston Parkway
New City, NL 33545
(505) 555-0077

James L. North
President

You aren't stuck with just white paper any more. Look at the many options that are available.

And look for bright borders. Here, the front side of the paper will probably be yellow, with the darker color as a border.

North Associates
7600 Weston Parkway
New City, NL 33545

North Associates

7600 Weston Parkway New City, NL 33545 (505) 555-0077

A simple underline graphic can make a card and letterhead really speak volumes. It's as though the red underline says "this is the last word."

North Associates

7600 Weston Parkway
New City, NL 33545
(505) 555-0077

James L. North
President

North Associates

7600 Weston Parkway New City, NL 33545

North Associates

7600 Weston Parkway
New City, NL 33545
(505) 555-0077

Experiment with shapes. This interesting design was done with just two elements: an elongated rectangle, and a couple of rounded rectangles. (See below.) What other shapes could you use to create interesting designs?

North Associates

7600 Weston Parkway
New City, NL 33545
(505) 555-0077

James L. North
President

These are the shapes that were used to create the designs above. With any page layout or drawing program, you have an infinite number of possible shapes with which to work.

North Associates

7600 Weston Parkway
New City, NL 33545

(505) 555-0077

North Associates

7600 Weston Parkway
New City, NL 33545

(505) 555-0077

James L. North
President

North Associates

7600 Weston Parkway

New City, NL
33545

Looking for a really unusual look for your card, letterhead and envelope? Look to the internet and view different website homepages for inspiration.

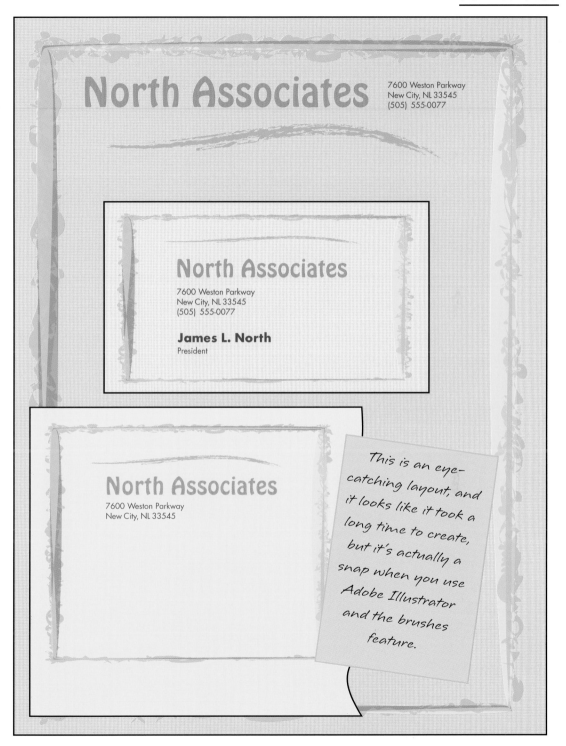

North Associates

7600 Weston Parkway
New City, NL 33545
(505) 555-0077

North Associates

7600 Weston Parkway
New City, NL 33545
(505) 555-0077

James L. North
President

North Associates

7600 Weston Parkway
New City, NL 33545

This is an eye-catching layout, and it looks like it took a long time to create, but it's actually a snap when you use Adobe Illustrator and the brushes feature.

North Associates

7600 Weston Parkway
New City, NL 33545
(505) 555-0077

Circles. With one letter inside. If the firm name is short enough, this can work quite well. Experiment with fonts and colors.

North Associates

7600 Weston Parkway
New City, NL 33545
(505) 555-0077

James L. North
President

North Associates

7600 Weston Parkway
New City, NL 33545
(505) 555-0077

North Assocs.

7600 Weston Parkway
New City, NL 33545
(505) 555-0077

North Assocs.

7600 Weston Parkway
New City, NL 33545
(505) 555-0077

James L. North
President

North Assocs.

7600 Weston Parkway
New City, NL 33545

Many fonts can be easily read with the top cut off.
A layout like this has an interesting look.

North Associates

The type is BIG and the message is BOLD. For many types of businesses, this is a very appropriate style.

North Associates
7600 Weston Parkway
New City, NL 33545
(505) 555-0077

James L. North
President

North Associates
7600 Weston Parkway
New City, NL 33545

North Associates
7600 Weston Parkway
New City, NL 33545
(505) 555-0077

North Associates

North Associates
7600 Weston Parkway
New City, NL 33545
(505) 555-0077

North Associates

James L. North
President

The type is big but the message is muted. The soft tones that blend in with the background make this a more subtle design than the one on the left.

North Associates
7600 Weston Parkway
New City, NL 33545

North Associates

North Associates

North Associates

North Associates

North Associates
7600 Weston Parkway
New City, NL 33545
(505) 555-0077

North Associates

James L. North
President

If you want to get someone's attention in a subtle way, put the firm name in a tall rectangle, but have the type in a muted tone, so it's not so overpowering. Experiment with various colors and fonts. Season to taste.

North Associates

7600 Weston Parkway
New City, NL 33887
(505) 555-0077
www.north.corp

Less is more. The small size of the type and the design elements literally shout "look at me!"

North Associates

7600 Weston Parkway
New City, NL 33887
(505) 555-0077
www.north.corp

James L. North
President

North Associates 7600 Weston Parkway
New City, NL 33887

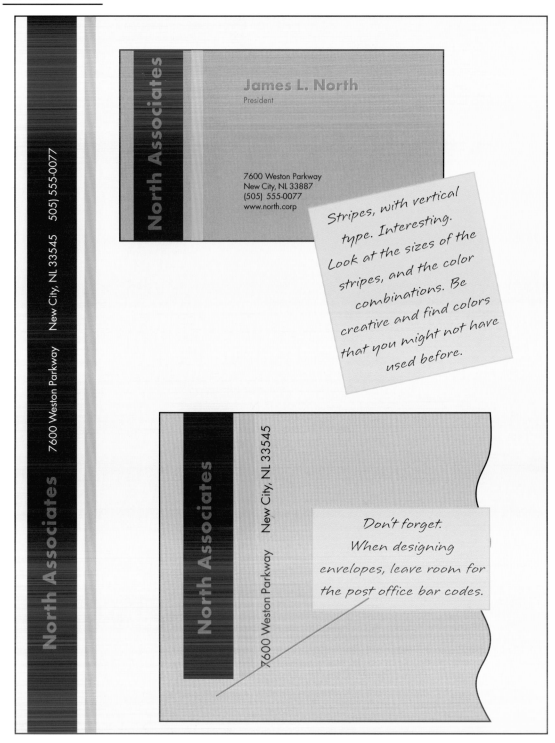

James L. North
President

7600 Weston Parkway
New City, NL 33887
(505) 555-0077
www.north.corp

North Associates

505) 555-0077 New City, NL 33545 7600 Weston Parkway North Associates

Stripes, with vertical type. Interesting. Look at the sizes of the stripes, and the color combinations. Be creative and find colors that you might not have used before.

North Associates New City, NL 33545 7600 Weston Parkway

Don't forget. When designing envelopes, leave room for the post office bar codes.

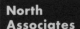

**North
Associates**

7600 Weston Parkway
New City, NL 33887
(505) 555-0077
www.north.corp

All of the company information is confined to a square. And the square shape is repeated at the bottom, with each square being a shade lighter than the one before it. Simple to execute, and a nice look.

**North
Associates**

7600 Weston Parkway
New City, NL 33887
(505) 555-0077
www.north.corp

James L. North
President

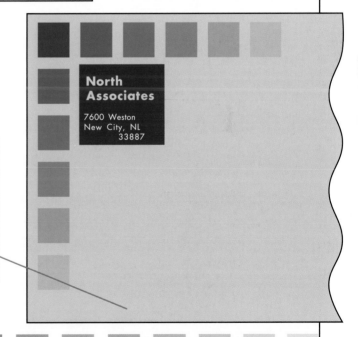

**North
Associates**

7600 Weston
New City, NL
33887

Once again, we've left room for the Post Office. Another opportunity to use our imagination when designing the envelope.

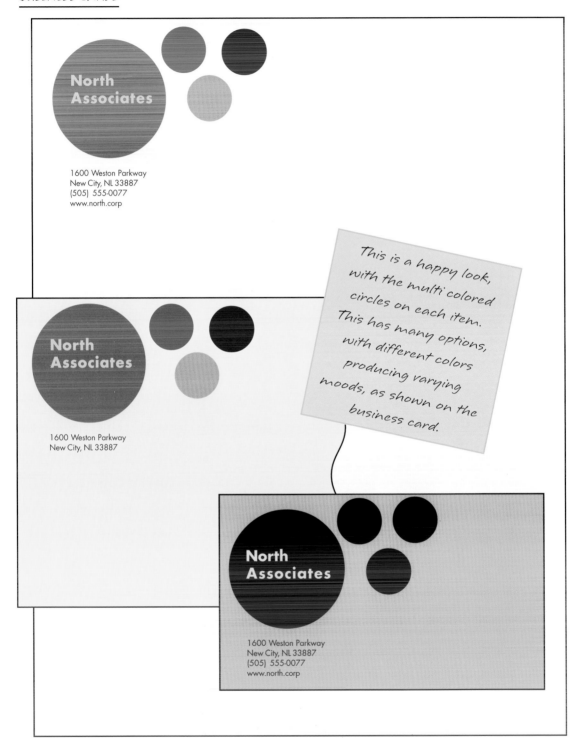

**North
Associates**

1600 Weston Parkway
New City, NL 33887
(505) 555-0077
www.north.corp

**North
Associates**

1600 Weston Parkway
New City, NL 33887

This is a happy look, with the multi colored circles on each item. This has many options, with different colors producing varying moods, as shown on the business card.

**North
Associates**

1600 Weston Parkway
New City, NL 33887
(505) 555-0077
www.north.corp

North Associates

1600 Weston Parkway
New City, NL 33887
(505) 555-0077
www.north.corp

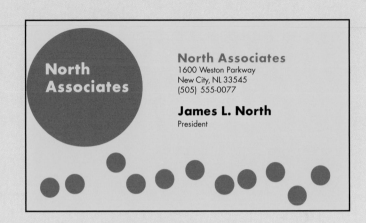

North Associates
1600 Weston Parkway
New City, NL 33545
(505) 555-0077

James L. North
President

The circle at the top is the foundation for the system. The circles at the bottom greatly add to the power of the image.

North Associates

1600 Weston Parkway
New City, NL 33887
(505) 555-0077
www.north.corp

**North
Associates**

7600 Weston Parkway
New City, NL 33545
(505) 555-0077

**North
Associates**

7600 Weston Parkway
New City, NL 33545
(505) 555-0077

James L. North
President

**North
Associates**

7600 Weston Parkway
New City, NL 33545

Think about the various shapes you could use. Circles and squares always work well, but there are many other shapes that you can create. This is just one possibility. Think outside the box and come up with others.

North Associates

7600 Weston Parkway
New City, NL 33545
(505) 555-0077

North Associates

7600 Weston Parkway
New City, NL 33545
(505) 555-0077

James L. North
President

North Associates

7600 Weston Parkway
New City, NL 33545
(505) 555-0077

A different approach to a partial outline of the items. This graphic has many possibilities, with different thicknesses, positions and colors.

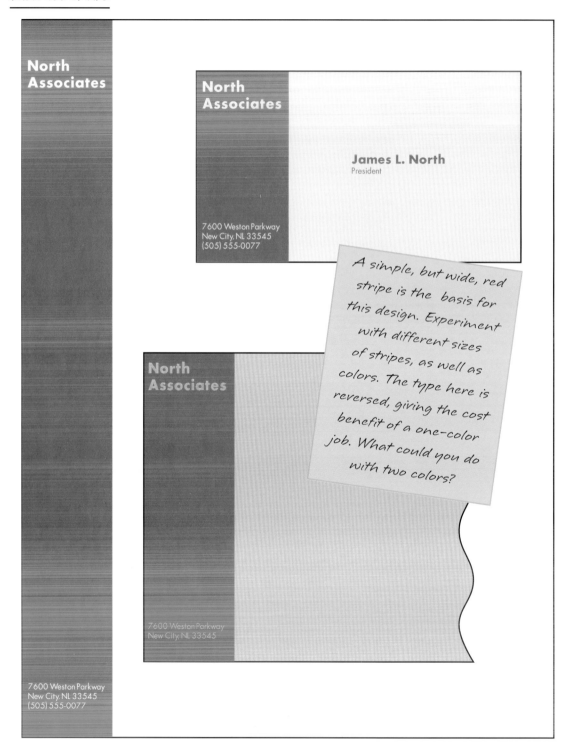

North Associates

North Associates

James L. North
President

7600 Weston Parkway
New City, NL 33545
(505) 555-0077

North Associates

7600 Weston Parkway
New City, NL 33545

A simple, but wide, red stripe is the basis for this design. Experiment with different sizes of stripes, as well as colors. The type here is reversed, giving the cost benefit of a one-color job. What could you do with two colors?

7600 Weston Parkway
New City, NL 33545
(505) 555-0077

**North
Associates**

**North
Associates**

James L. North
President

7600 Weston Parkway
New City, NL 33545
(505) 555-0077

Circles and squares, one on top of the other. The lighter circle leaves plenty of room for the letter, and the varying shades are a nice look. This is a one-color printing job, so the budget is not an issue.

7600 Weston Parkway
New City, NL 33545
(505) 555-0077

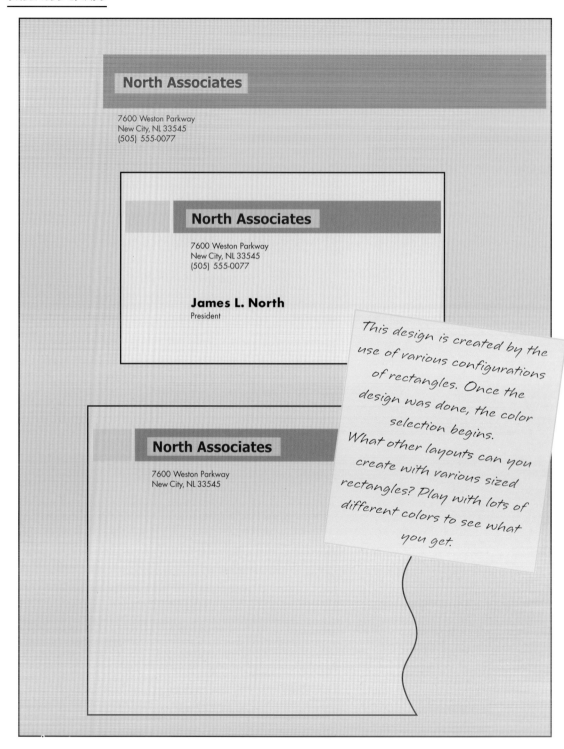

North Associates

7600 Weston Parkway
New City, NL 33545
(505) 555-0077

North Associates

7600 Weston Parkway
New City, NL 33545
(505) 555-0077

James L. North
President

North Associates

7600 Weston Parkway
New City, NL 33545

This design is created by the use of various configurations of rectangles. Once the design was done, the color selection begins.
What other layouts can you create with various sized rectangles? Play with lots of different colors to see what you get.

North Associates

North Associates

James L. North
President

7600 Weston Parkway
New City, NL 33545
(505) 555-0077

Lines and rectangles make this design. The symmetry of the top and the bottom give added interest. Experiment with these two shapes, putting them in different spatial relationships. The card show some examples of variety.

7600 Weston Parkway
New City, NL 33545
(505) 555-0077

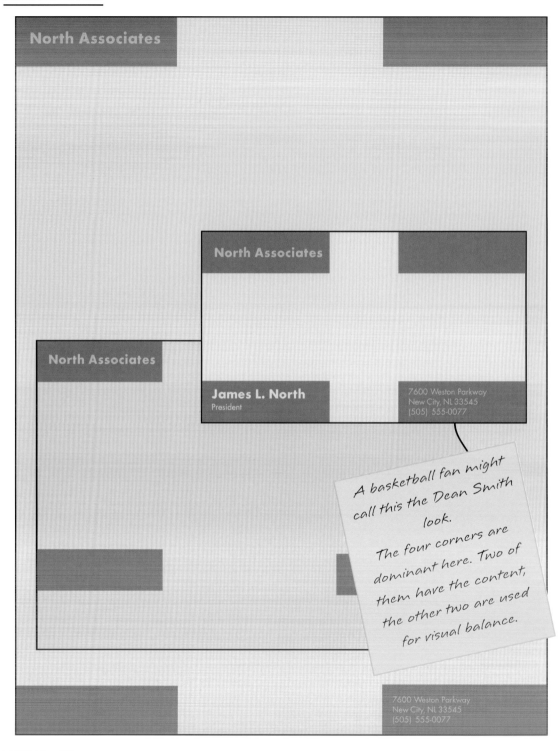

North Associates

North Associates

North Associates

James L. North
President

7600 Weston Parkway
New City, NL 33545
(505) 555-0077

A basketball fan might call this the Dean Smith look.

The four corners are dominant here. Two of them have the content, the other two are used for visual balance.

7600 Weston Parkway
New City, NL 33545
(505) 555-0077

North Associates

7600 Weston Parkway
New City, NL 33545
(505) 555-0077

Two factors make this a powerful design. The initial in the center, and the green lines are the same linear position as the main strokes in the letter N.

N

How would you use other letters: what would the accent lines look like?

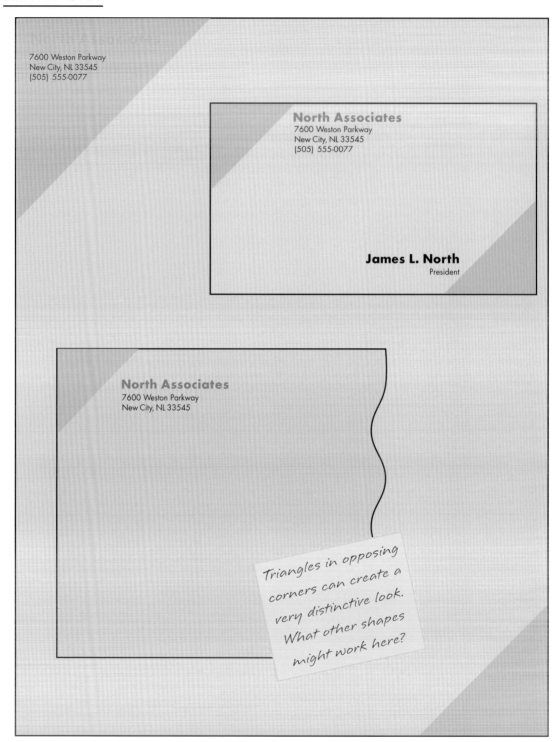

7600 Weston Parkway
New City, NL 33545
(505) 555-0077

North Associates
7600 Weston Parkway
New City, NL 33545
(505) 555-0077

James L. North
President

North Associates
7600 Weston Parkway
New City, NL 33545

Triangles in opposing corners can create a very distinctive look. What other shapes might work here?

North Associates
7600 Weston Parkway
New City, NL 33545
(505) 555-0077

North Associates
7600 Weston Parkway
New City, NL 33545
(505) 555-0077

James L. North
President

North Associates
7600 Weston Parkway
New City, NL 33545

Try a combination of thick and thin lines. And experiment with the positioning of the lines, as well as the colors. This is a very clean, classy look.

North Associates
7600 Weston Parkway
New City, NL 33545
(505) 555-0077

This is actually a one-color printing job, but by having 4 tones of green for the border, it has a much brighter appearance than you would expect for a budget job.

North Associates
7600 Weston Parkway
New City, NL 33545
(505) 555-0077

James L. North
President

DECember Associates

7600 Weston Parkway
New City, NL 33545
(505) 555-0077

If you have a client with initials that can be worked into a design, you can make them big, really BIG, with an interesting effect.

DECember Associates

7600 Weston Parkway
New City, NL 33545
(505) 555-0077

James L. North
President

DEC

DEC

James L. North President

North Associates 7600 Weston Parkway New City, NL 33545 (505) 55

The line at the bottom of each element stands out from the pack. Experiment with line thickness, type positions, as well as color combinations.

James L. North President

North Associates 7600 Weston Parkway New City, NL 33545 (505) 555-0077

James L. North President

North Associates 7600 Weston Parkway New City, NL 33545 (505) 555-0077

North Associates 7600 Weston Parkway New City, NL 33545 (505) 555-0077

N

North Associates
7600 Weston Parkway
New City, NL 33545
(505) 555-0077

N

North Associates
7600 Weston Parkway
New City, NL 33545
(505) 555-0077

James L. North
President

This layout is fairly simple, but works well. A couple of different options are shown on the 2 card layouts here.

N

North Associates
7600 Weston Parkway
New City, NL 33545
(505) 555-0077

James L. North
President

A&B

A&B Associates

7600 Weston Parkway
New City, NL 33545
(505) 555-0077
www.a-and-b.corp

Got initials for a company name? Use them. Get creative with size, placement, and colors. The 3 cards here show 3 different approaches to using initials.

A&B Associates

7600 Weston Parkway
New City, NL 33545
(505) 555-0077
www.a-and-b.corp

James L. North
President

A&B
A&B Associates

7600 Weston Parkway
New City, NL 33545
(505) 555-0077
www.a-and-b.corp

James L. North
President

a&b

a&b Associates

7600 Weston Parkway
New City, NL 33545
(505) 555-0077
www.a-and-b.corp

James L. North
President

North Associates
1600 Weston Parkway
New City, NL 33545
(505) 555-0077
w w w . n o r t h . c o r p

North Associates
1600 Weston Parkway
New City, NL 33545

w w w . n o r t h . c o r p

James L. North
President

North Associates
1600 Weston Parkway
New City, NL 33545

w w w . n o r t h . c o r p

Type, and two vertical lines. That's the whole design concept here. Yet, it works. The forced letterspacing makes it a little out of the ordinary.

North Associates

1600 Weston Parkway
New City, NL 33545
(505) 555-0077
w w w . n o r t h . c o r p

James L. North
President

North Associates

1600 Weston Parkway
New City, NL 33545
(505) 555-0077
w w w . n o r t h . c o r p

North Associates

1600 Weston Parkway
New City, NL 33545

w w w . n o r t h . c o r p

Putting all of the information into a rectangle is a simple solution that draws immediate attention to the space. Using the wide letterspacing gives the layout an unusual touch.

North Associates

7600 Weston Parkway
New City, NL 33545
(505) 555-0077

to:

The border around the
letterhead has a little
different twist, with a box
where the inside address
should go.. This same look
appears on the business
card, with the name and
title position.

James L. North
President

North Associates
7600 Weston Parkway
New City, NL 33545
(505) 555-0077

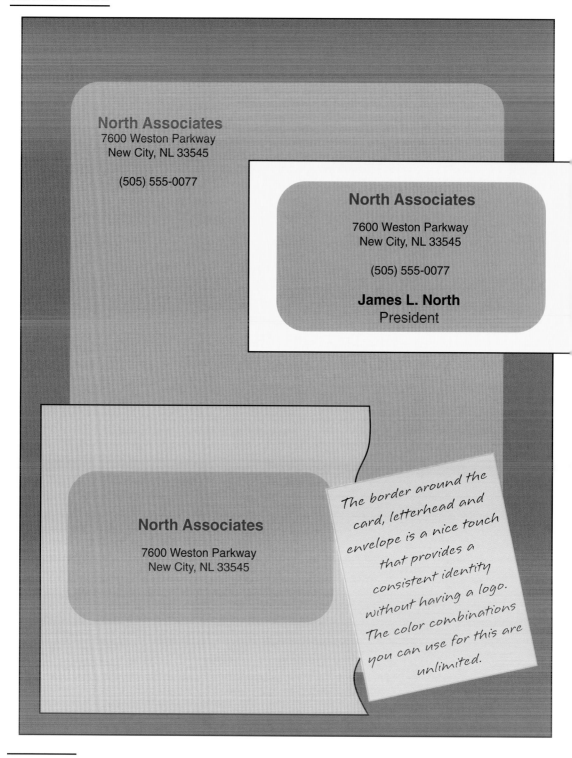

North Associates
7600 Weston Parkway
New City, NL 33545

(505) 555-0077

North Associates

7600 Weston Parkway
New City, NL 33545

(505) 555-0077

James L. North
President

North Associates

7600 Weston Parkway
New City, NL 33545

The border around the card, letterhead and envelope is a nice touch that provides a consistent identity without having a logo. The color combinations you can use for this are unlimited.

North Associates

7600 Weston Parkway
New City, NL 33545

(505) 555-0077

Abstract designs work well on the back of cards and letterheads, but they can also be used to frame the front of these items. With this concept, the design possibilities are unlimited.

North Associates

7600 Weston Parkway
New City, NL 33545

(505) 555-0077

James L. North
President

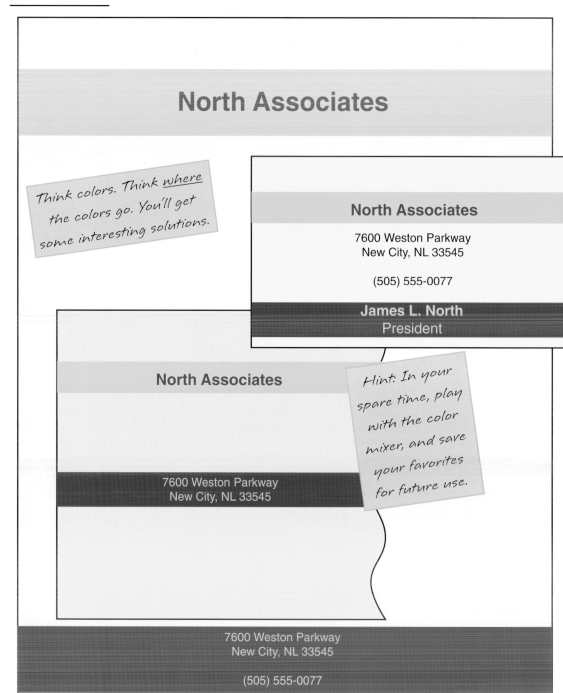

North Associates

Think colors. Think <u>where</u> the colors go. You'll get some interesting solutions.

North Associates

7600 Weston Parkway
New City, NL 33545

(505) 555-0077

James L. North
President

North Associates

7600 Weston Parkway
New City, NL 33545

Hint: In your spare time, play with the color mixer, and save your favorites for future use.

7600 Weston Parkway
New City, NL 33545

(505) 555-0077

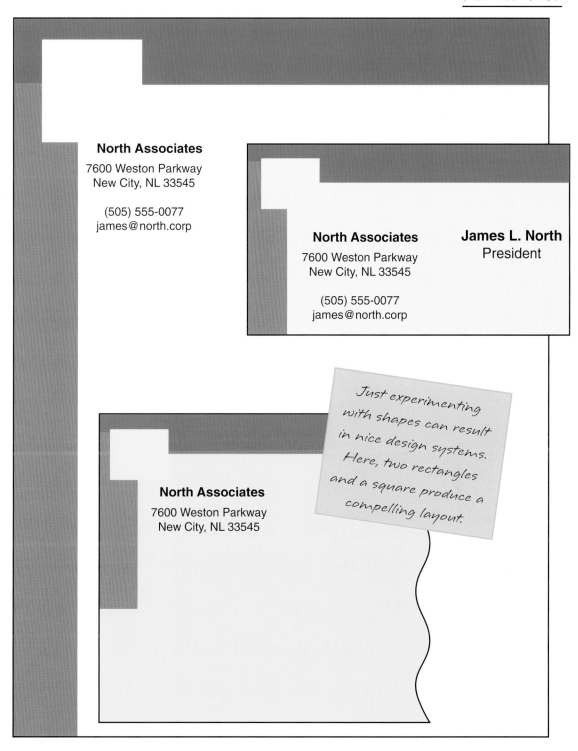

North Associates

7600 Weston Parkway
New City, NL 33545

(505) 555-0077
james@north.corp

North Associates

7600 Weston Parkway
New City, NL 33545

(505) 555-0077
james@north.corp

James L. North
President

Just experimenting with shapes can result in nice design systems. Here, two rectangles and a square produce a compelling layout.

North Associates

7600 Weston Parkway
New City, NL 33545

North Associates

7600 Weston Parkway
New City, NL 33545
(505) 555-0077

Circles work as a background element. Here, the circles are a shade darker than the background. This gives a subtle, classy look.

North Associates

7600 Weston Parkway
New City, NL 33545
(505) 555-0077

James L. North
President

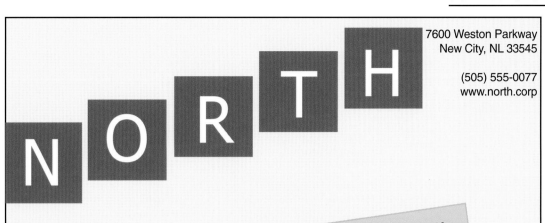

7600 Weston Parkway
New City, NL 33545

(505) 555-0077
www.north.corp

For short firm names, you can use squares and get a stairstep effect. Note that the card has a variation on the type. The letters go to the edge of the colored boxes. Experiment with type and see what else you can create.

James L. North
President

7600 Weston Parkway
New City, NL 33545

(505) 555-0077
james@north.corp

North Associates
7600 Weston Parkway
New City, NL 33545

North Associates
7600 Weston Parkway
New City, NL 33545

For a company with some geographic connection to the mountains, or the hills, a layout like this is very appropriate, as well as being an attention grabber.

North Associates

7600 Weston Parkway
New City, NL 33545

(505) 555-0077
james@north.corp

James L. North
President

Cool software for creating exciting images

Painter > Double Helix

Painter is a program that has "spray nozzles" to let you create images just by laying down a line. Some of them are shown here. They are great for use as an icon at the bottom of cards and letterheads. (shown here full size on cards.)

Painter > Leaves

Painter > Leaves

Painter > Playing Cards

Painter > Rope

Painter > Rose

Painter > Wave Mosaic

Painter > Stucco

Juice Drops has layered Photoshop files. Imagine: this graphic is made up of 20 layers. You can create a number of different looks by turning the different layers off or on. These are great for backgrounds, and you can also extract a "logo" from the image. For example the globe logo below came from the original illustration above. A good use of these would be to use the globe as the main icon, and the original file as the image on the back of cards and letterheads.

digitaljuice.com

The image above is the original Juice Drops file. Below, this image was extracted from the top one by turning off layers in Photoshop. This has many uses for designers.

The original Juice Drops image, shown at top, was changed to the icon at the bottom. Layered Photoshop files make this possible.

The original Juice Drops image has continents and flags. The flag portion was extracted from a single layer, and copied below. This makes a great "print it on the back" image for letterheads and cards.

The heavily detailed original Juice Drops image above is changed into a stark-desert-like visual by selecting layers.

The original Juice Drops image has continents and currency. With the money portion removed, we are left with the continents.

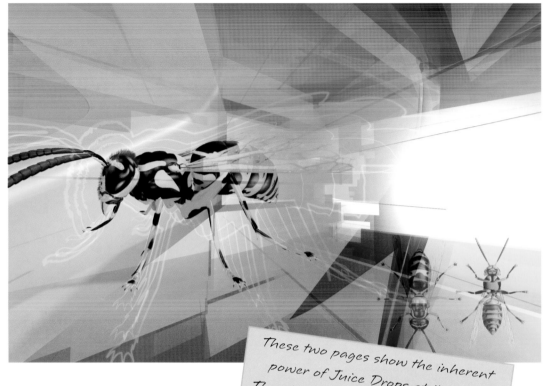

These two pages show the inherent power of Juice Drops at its best. The above image can be a great back for cards and letterheads. The extracted single images of the wasp and butterfly are good images for a primary icon.

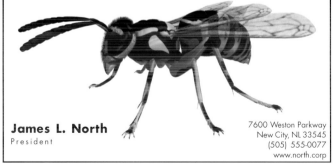

North Associates

James L. North
President

7600 Weston Parkway
New City, NL 33545
(505) 555-0077
www.north.corp

Above, the full image can be used for ads, as well as identity items. And at right, you see how one part of the piece can be used on cards. In this case, there are many butterflies, so you can have numerous different butterflies on cards as an option.

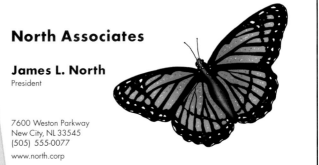

North Associates

James L. North
President

7600 Weston Parkway
New City, NL 33545
(505) 555-0077
www.north.corp

Here are two more of the Juice Drops images. There are thousands in the full collection, and all of them are in Photoshop layers. Besides being a handy tool, they also spark your imagination.

A company called Alien Skin has some great Photoshop plug-ins. The options they provide let you quickly create unusual images that are highly creative.

Their products include:
- Eye Candy 4000
- Xenofex
- Splat

Examples of these products are on the next several pages.

Eye Candy 4000 > Bevel Boss

Eye Candy 4000 > Corona

Source: www.alienskin.com

Eye Candy 4000 > Jiggle

Eye Candy 4000 > Fire

Eye Candy 4000 > Melt

Eye Candy 4000 > Squint

The software "Adobe Illustrator 10" has a number of features that help you design images. It enables you to have a wide range of control over the image, as you change colors, adjust lighting, alter the positions of image segments, etc. For example, the image shown here, is a variation of Blue Goo from Illustrator.

Illustrator 10 > Blue Goo

Illustrator 10 > Copper

Two more examples from Illustrator:
Copper and Camouflage.
Imagine these on the backs of business
cards and letterheads.
The possibilities are endless.

Illustrator 10 > Camouflage

Illustrator 10 > Light Bulbs

Illustrator 10 > Flames

Illustrator 10 > Fish

Illustrator 10 > Honeycomb Silk

Eye Candy 4000 > Water Drops

Illustrator 10 > Jungle Stripes

Eye Candy 4000 > Light Pegs

Splat > Metal Plate

Splat > Metal Plate
Eye Candy 4000 > Bevel Boss > Shadowlab

Splat > Stamp > Buttons

Splat > Stamp > Fall Leaves

Splat > Resurface > Concrete

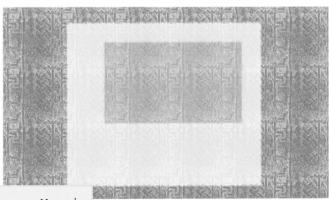

Xenofex > Mosaic

Splat > Halftone Dots

Splat > Halftone Lines

Splat > Torn Paper

More examples from Illustrator 10. Can you think of businesses that might be able to use these for their letterheads and business cards?

Splat > Tile

Splat > Wicker

Splat > Torn Paper

Splat > Fur

Xenofex > Crumple

Xenofex > Flag

Xenofex > Flag

If you'd like to create a logo with a corporate flag, Xenofex makes it easy. Just create the image as a standard shape: rectangle or square. Put the elements into the design, then the Xenofex filter inside Photoshop instantly creates the flag wave. You have slider controls that let you control the amount of wave, etc.

Xenofex > Electrify

Splat > Resurface > Canvas

Splat > Frame > Art Nouveau

Splat > Starfish Fill

Xenofex > Burned Edges

Xenofex > Sunglow > Lightning

Splat > Seashells Fill

Splat > Art Nouveau Border

Splat > Stamp > Baseballs

Xenofex > Constellation

Xenofex > Mezzotint

Xenofex > Puzzle

The possibilities are endless using these examples. Experiment and try different techniques to "capture" your clients image.

Xenofex > Puffy Clouds > Lightning

Splat > Edges: Rough

Splat > Edges: Pixels

David E. Carter is the bestselling author/editor in the history of graphic design books.

In 1972, when there were *no* logo design books available, Carter produced *The Book of American Trade Marks, Volume 1.* (Seventeen publishers rejected that book before it was published; it went on to become one of the bestselling graphic books ever.) To date, he has written or edited nearly 90 books on the topic of corporate identity.

©1999 by Al Hirschfeld. Drawing reproduced by special arrangement with Hirschfeld's exclusive representative, The Margo Feiden Galleries, Ltd., New York.

By 1978, Carter had produced 10 books related to corporate image; that year, he conducted seminars for *Advertising Age* in New York, Chicago, and Los Angeles. His corporate identity seminars eventually expanded around the world to locations such as São Paulo, Brazil, Helsinki, Finland, and Singapore.

In 1989, Carter established a major presence in Asia as a design consultant. Through affiliate offices in Bangkok and Jakarta, he managed identity projects for a large number of multinational firms in the Pacific Rim.

While corporate identity is Carter's specialty, he has had a variety of other business interests. In 1977, he founded an advertising agency that soon qualified for AAAA membership. He wrote and produced an ad that won a Clio Award in 1980. In 1982, he started a TV production company and won seven Emmy Awards for creating innovative programs that appeared on PBS. He also produced a large number of comedy segments which appeared on *The Tonight Show Starring Johnny Carson.*

His first book for general audiences, *Dog Owner's Manual*, is a humorous book and was published in the spring of 2001 by Andrews McMeel.

Currently, he is working on several new corporate identity books, as well as editing the annuals, *American Corporate Identity* and *Creativity.*

Carter worked his way through school, earning an undergraduate degree in advertising from the University of Kentucky, and holds a master's degree from the Ohio University School of Journalism. More recently, Carter returned to the classroom to earn an MBA from Syracuse University in 1995. He graduated from the three-year Owner/President Management program (OPM) at the Harvard Business School in 1998.